RIVER DERWENT

From Sea to Source

H. C. IVISON

AMBERLEY

First published 2013

Amberley Publishing
The Hill, Stroud
Gloucestershire, GL5 4EP

www.amberley-books.com

British Library Cataloguing in Publication Data.
A catalogue record for this book is available from the British Library.

ISBN 978 1 4456 1521 9 (print)
ISBN 978 1 4456 1544 8 (ebook)

Typeset in 10pt on 12pt Sabon.
Typesetting and Origination by Amberley Publishing.
Printed in the UK.

Contents

Acknowledgements

I would like to record my thanks to friends and fellow researchers, many of whom are named within this book, and to others who wish to remain anonymous. Thank you for your generosity, experience and knowledge. Special thanks to Mr T. Harrop, Mr P. Lishman, Mr D. Woodruff, Mr K. Irving, M. Jackson, M. McKintyre and the Workington Musical Festival Committee, Mr and Mrs I. McCleary, Mr and Mrs R. Steele, Mr and Mrs J. Thompson, Mr and Mrs A. Walton, Mr and Mrs A. Smith, Dr F. Fitzgerald, Mr E. Ivison, Dr P. K. Ivison, Mr N. D. Ivison, Mr G. Kirkpatrick, Ms M. Birkett, Mrs Spedding, Mark Graham, Don O'Meara and David Jackson of Grampus Heritage, Andy Airey, George Fishers Ltd of Keswick, and Philip Corkhill of 'Picture It'.

Last but by no means least, the staff of Workington Library, especially Lyn. Editor Steve Johnston and Nicole Regan, of the *Times & Star* newspaper, owned by West Cumberland Newspapers.

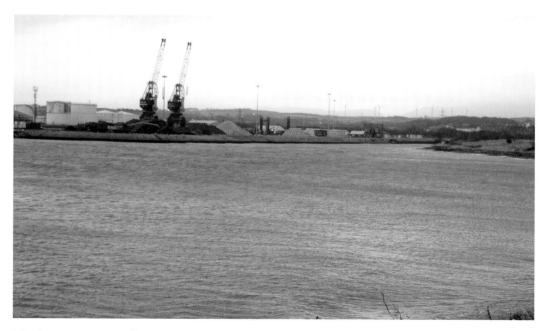

The River Derwent spilling into the sea at the harbour mouth.

1
The River Derwent

The River Derwent springs from the heart of Lakeland to speed its tumbling, twisting way to the beautiful Solway coast. On its journey it races through a landscape which is a mixture of the historic and the contemporary, an important part of the county's past, present and future.

Sometimes called 'the river of saints and sinners', the lower reaches of the River Derwent and its adjacent shoreline were for centuries well-used recorded traditional smuggling haunts. The saints, represented by St Cuthbert, St Herbert of Derwentwater fame, and other Holy Brothers, did, we are told, use the Derwent to expedite their journey through the hinterlands of Cumbria. Some of the oldest 'worship' sites, not only in Cumbria but in the North of Britain, are said to be situated beside this river.

This use of the river makes perfect sense, as water would be by far the safest and most convenient way through what would have been, for the most part, a heavily wooded landscape. For centuries water, both river and sea, was regarded as the usual form of travel for those with the practical means, which would have included a reasonable portion of the local population.

Well into the nineteenth century, it was still relatively common to travel from Workington to Cockermouth market by boat, or by sea from Whitehaven to Liverpool for a day's shopping.

There are, of course, other rivers named Derwent, but to the people of Cumbria their river is special, a much-used part of everyday life, past, present, and on into this lovely and varied county's future. This river has been, and is still, an active part of both industry and leisure; it has also been both the cause, and instrumental in the cure, of disease.

The name Derwent, 'river of oaks', and those of the surrounding hinterland give many clues to this waterway's ancient usage, lineage and ancestry. The Derwent begins in Esk Hause above Borrowdale, divides around Seathwaite Fell to converge in upper Borrowdale, then, all the while gathering tributaries, tumbles down the valley to its named lake, Derwentwater.

According to the wonderful Diana Whaley, one of the translations of Borrowdale itself is the Valley of the 'Borgara – the river by the fortification'. In her excellent *Dictionary of Lake District Place Names*, she also says that the name Borghara (Borgara) is recorded as being used for the upper Derwent as early as the thirteenth century.

After Derwentwater, the river enters Bassenthwaite Lake – the locally preferred name being Bass. The Derwent leaves Bass at its northern end by Ouse Bridge, now a fully formed river snaking and racing its way to the sea, all the way gathering the speed and power to become

one of the fastest rivers in Europe. The Derwent is a spate river, falling some 2,500 feet in elevation and travelling around 25 miles, source to sea. Its journey passes villages, industries past and present, churches, a castle, Roman forts, bridges old and new, flora, fauna, sport, three major towns – Keswick, Cockermouth, Workington – and so much more. This and the millennia of history, is the Derwent.

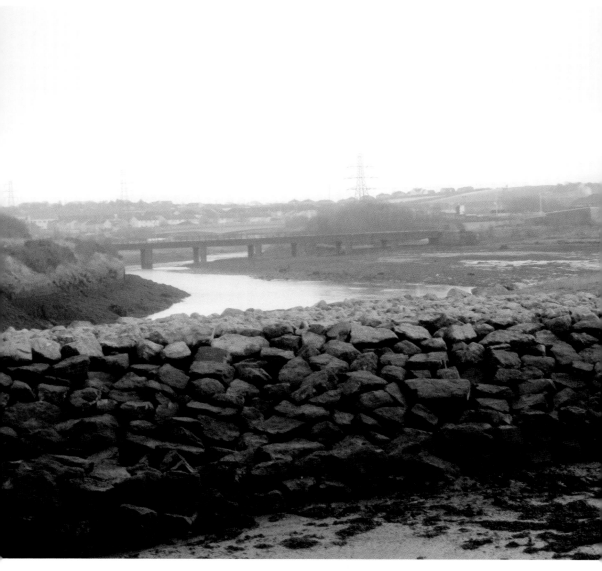

'The Last Mile': the Derwent passing under the Workington–Maryport railway bridge, with the docks to the left of the picture.

2

From River Mouth to Marron Junction

The River Mouth

The river mouth and harbours have obviously changed from generation to generation. It is accepted that the hinterland and coast around the mouth of the River Derwent has been inhabited for several thousand years. There is evidence of iron hearths and smelting within, around and above what was probably a wide delta, and also examples of terracing on the banks around the river's lower reaches.

There is also good evidence that the land, for the most part, would have been heavily wooded. This, along with other advantages, such as fish, game, running water, and easy transport, make it so very easy to see what first attracted settlers to this area. Minerals, including ironstone, were plentiful, and early smelting was widespread within Cumbria, the 'village' in Ennerdale being just one of many examples, and many more have not been found.

There is some dispute concerning just where the Derwent's mouth was. Most of this dispute concerns (for Cumbria) the fairly recent past, the last 2,000 years or so. The coastline around the Derwent's mouth has been helped, or hindered depending on your point of view, by industry. It certainly has, and is still, being changed and altered by industrial development. The windmills constitute one recent example. According to local maps, the river mouth appears to have moved consistently south, until the building of the present breakwater, which seems to be moving the flow once more to the north.

Broad agreement seems to have settled on Siddick, upcoast to the north, as being the site of the river mouth around the Roman era. Siddick, translated as 'Sea Dike', is now landlocked, if in parts somewhat 'swampy'. Among the factories in this area is Thames Board, who take their water from the River Derwent, and on whose land Siddick Ponds, a renowned wildlife sanctuary, is located.

The main river mouth as we see it today is to the north and known as the North Gut. There is a considerably smaller South Gut which breaks from the river to feed a number of streams before meeting the sea at Workington Harbour. This harbour has a tidal range of 30 feet, not unusual on the Solway, and is well used by both pleasure craft and local fishermen. A tongue of land that divides North and South Guts is accessible by footbridge just beyond the viaduct above the harbour.

A great deal of land on and around the present harbourside was reclaimed from salt marsh by the dumping of ships' ballast here in the mid-1800s. This and the viaduct itself now make it difficult to imagine what a prominent landmark St Michael's church and its predecessors must have been, long before the advent of either rail or viaduct.

This present building was rebuilt and restored after a fire around 1887. The church was again gutted by fire in 1994, leaving only the shell intact. An archaeological dig that preceded the latest restoration proved local folklore to be correct in stating that there have been a number of preceding churches on this site. Sitting high on the Derwent's south ridge, the succeeding buildings would have been visible from the sea for a considerable distance and would have dominated the river entrance, gazing out over what was then sea marsh and tidal plane. This present church and several of its predecessors were named St Michael, but there is believed to have been a much earlier appellation, or appellations, which have not, to date, been successfully traced.

The name 'Priest Gate' is still associated with the area around the present St Michael's church, and it is probable that it was once the name of a watergate, it being possible in the past to approach the church mound by boat. Obviously the site is now landlocked, and has been for some centuries.

If you are fortunate enough, as I was some years ago, to stand on the tower of St Michael's, you get a real idea of how close to sea and river this church still is. You get the somewhat dizzy impression that you are looking straight down into the South Gut and the harbour.

The North Gut is the mouth of the river proper, the Derwent spills into the sea with the Prince of Wales Dock on its upcoast or northern side.

The Port of Workington

Affectionately called 'Workington Docks', officially, and more accurately, it is now the Port of Workington. This complex dominates the north side of the river mouth.

In the eighteenth century the main export cargo was coal. Changing and adapting as the town's industry grew and progressed, Workington became an independent port in 1850. The year 1865 saw the building of the Lonsdale Dock, which was deepened and widened in the 1920s and subsequently renamed the Prince of Wales Dock. It was opened by Edward, Prince of Wales, on 30 June 1927.

This was a busy port that latterly served the town's rail and steel industry before they closed; one of port's main current cargos now is wood and wood pulp for Thames Board.

Smuggling and Smugglers

Upriver by boat, loaded onto packhorses, at suitably secret locations, on through the lakes, towards many and varied destinations; this was the regular route for some smuggled cargoes. Workington was by no means the only town on the Solway that saw, or chose not to see, regular 'trade', but Workington had the Derwent.

A wide river mouth with shallow tidal waters, the Derwent and the coast around its exit to the sea have played their part in many a smuggler's tale. Smuggling was rife, and an accepted

part of life. This trade was probably at its height around the sixteenth and seventeenth centuries, but dates are by no means exact. Often over-romanticised, smuggling was a dangerous trade, chases and skirmishes with the 'excise men' have been much recorded, and according to these accounts, they were sometimes brutal, on both sides.

We will probably never know what volume of 'trade' travelled upriver. Folklore might tell us of 'stashes' or name certain points where mule and boat were said to meet, but routes and beats were guarded, often viciously, and regarded as the property of certain families on almost an hereditary basis. There are very few contemporary accounts other than incidents with the excise men, who on the whole appeared to watch for landing locations. Perhaps it made more sense and took less manpower to apprehend the cargoes before they were spirited inland.

We forget how wild the Lake District must have appeared, indeed how wild it was: beaten-earth, rock-strewn tracks and unpredictable weather capable of changing in minutes. (We still have that.) For those who were familiar with the valleys and passes, it had to be an ideal way to escape pursuit. It is from folklore that we hear of many Lakeland routes thought to be traditional smugglers' tracks. From Derwentwater, up the Valley of Watendlath, over the pass to Thirlmere, is just one famous trail said, with some justification, to have been much favoured.

Strangely, perhaps, it can often be ghost stories that point us to smugglers' trails, shoreline and inshore: tales of creatures with red eyes and shaggy manes, wraiths and phantom horses. Some of these tales are suspected of being designed to frighten away the curious. The red-eyed shaggy creature known as a 'Shore Boggle' has been recorded as having beaten people brutally, and even of killing. An odd thing for a ghost.

It is folklore that tells the 'ideal' Cumbrian coastal smugglers boat was called a 'Kat', broad in beam, shallow in draft, with a high, graceful stern and prow. These boats were ancient in form and could be steered by either oar or pole, being ideal for slipping over the most difficult of shallows, marsh and mud, and at home in rivers, yet also controllable and stable when at sea. Sadly, no examples of these boats are known to survive, we only have their description, and the odd lithograph which could show such a craft tucked among others.

However, while on holiday in Shetland, when visiting a small local museum, I found myself looking at a black painted boat about 8 feet long, which could only be described as a Kat! Speaking to our guide I was told that it was simply their traditional form of in-coast rowing boat. This form of vessel had been in common use up to the early nineteenth century, and was thought to be ancient in design and Norse in origin. Coincidence is strange.

Workington

Sitting at the river mouth, Workington is the first of three major towns encompassed within the Derwent's length. The name itself is thought to come from Wyrkinton, or something very like it. There are almost as many spellings as there are ways to pronounce it. But it is now broadly agreed that the name is Norse. Once again, whoever the invaders were, the broad Derwent mouth apparently proved to be an inviting access road inland.

The town appears on the Bodleian map around 1300. This map shows a church with a spire, roughly in the same location as St Michael's. A building is marked that could be Curwen Hall, as it has a square tower, along with some cottages near the coast. The map also shows what could be the North Gut and South Gut at the River Derwent's mouth.

For many centuries Workington was virtually an upper and lower town, with drift mine and marshland between. In fact there are theories that at some period within the town's past, upper and lower each had separate identities and names; if so, all trace appears to have gone.

The upper main part of the town gathered around Workington Hall, now a Grade I listed ruin. The hall is set high above the river meadows on the left of the A66 as it begins its climb away from the coast. On the right of this road, opposite the hall grounds, there still survives the fine square and buildings of a Georgian town with, if old maps and local traditions are to be believed, many more ancient buildings beneath. In my opinion and experience, local traditions usually have a good basis of accuracy.

The lower town gathered around the coast and river mouth. A mixture of industrial and domestic Georgian, Victorian, and Edwardian buildings, many built over and often incorporating much older foundations, this area was and is called the Marsh and Quay.

The Marsh was built literally on sea marsh that had been reclaimed over the years. A loop of railway line traditionally divided the Marsh from the Quay, making a clear, practical, local distinction. It would seem that the Quay originally grew up around and spread from the quayside itself. Together the Marsh and Quay were a vibrant community until the very recent past. The area is now in the process of being redeveloped.

Over the centuries various houses, hostelries and commercial premises were built and rebuilt in between the two communities, growing mainly along the ridge south of the river. Hutchinson in his *History of Cumberland* (1774) said that the town had between 1,000 and 1,200 houses and a population of 6,000, while Jollie's *Cumberland Guide and Directory of 1811* tells us that 'Workington has increased rapidly of late years, and many handsome buildings have been erected'. But essentially Workington became one large cohesive town in mid- to late nineteenth century.

The town's market charter was granted by Elizabeth I in 1573. So, in retrospect, the Queen can't have been too incensed by the local, then current, Lord of Curwen giving the fugitive Queen Mary shelter in 1568.

Up to the 1960s Workington had two markets, and two traditional market places: Low Market and High Market. The Low Market was held each Wednesday on Falcon Place, a traditional market place beside St Michael's church. The much older name for Falcon Place is Hagg Hill, and it was once the site of the town stocks. 'Hagg' is thought to stem from 'peat hagg'; it was probably built over marsh as a great deal of the town is. But in Cumbria, hagg has, for centuries, been traditionally used to describe 'wise woman'.

High Market was held each Saturday in the old Georgian market place at the top end of town. There was also an old covered market here, now sadly roofless. There is said to have been a market cross somewhere around this general area, but there is some debate as to exactly where. Nearby, Portland Square is sometimes given as the location of the first 'high' market place. There were buildings here in the 1500s and it is much closer to Workington hall. The hall's oldest part is from around 1100.

Now the town has a new town centre (its second) and revitalised retail outlets, but the size and shape of Workington as we see it today, indeed what most people would now call Workington was built as the steelworks and other industries grew and flourished around the 1860–80s. It is often said that Workington grew with iron and steel and expanded with rail. But these were not the only industries to bring prosperity to the area. Coal and shipbuilding, especially 'king' coal, both played vital parts in the local area's earlier expansion.

Workington is an old and historic town, with connections to some fascinating, famous, or perhaps infamous, figures. It is also, by repute, one of the most haunted towns in Cumbria.

St Cuthbert

Workington and the Derwent mouth are quoted as the place where 'St Cuthbert's body sought the sea'. This is associated with the often-repeated story of the removal of Cuthbert's body from Whithorn and its journeying around Cumbria, escorted and protected by brother monks to prevent the saint's remains from falling into Danish hands. We are told that, before his death, Cuthbert had requested that his bones be kept safe from these invaders.

Famously the escorting party with their charge had attempted to return to Whithorn from Workington, but were washed back several times and finally defeated by an angry sea with tremendous waves – not uncommon on this beautiful and often dangerous stretch of water. Taking the storm as an omen, the monks delayed their return, months and sometimes years being quoted.

In his lifetime Cuthbert appears to have been no stranger to Cumbria, or the Derwent. There was a famous friendship between Herbert of Derwentwater fame and Cuthbert. It is often stated that the only time Herbert left his island sanctuary was to meet Cuthbert, their meetings taking place yearly. On one famous occasion, these saints are said to have met in Carlisle when Cuthbert was travelling to an ordination of Deacons. The usually accepted year given for this meeting is around 686.

It is also more than probable that Cuthbert was in the habit of joining Herbert on his Derwentwater island. That St Cuthbert preached at 'Cross Field', situated on the outskirts of modern Keswick and now the site of Crosthwait church, has never been disputed. Such was the friendship and empathy between Herbert and Cuthbert that they are said to have prayed that God would take them to himself on the same day. We are told that their prayer was granted within a year of their meeting in Carlisle, as the given date for their deaths is 20 March 687.

Mary Queen of Scots

Mary Stuart, Queen of Scots, Queen Dowager of France to use her full title, landed in Workington on the evening of 16 May 1568. Controversy has followed the how and why ever since. It is disputed and argued over as to how many followers she had. Was the young queen expected? Where exactly did she land?

The most commonly accepted version of the story is that she came ashore somewhere around the Derwent mouth. Modern research seems to agree that the tide would take her there, whether

to north or south of the river is still, and probably will continue to be, a matter of debate. Here she rested in some fishermen's cottages and was given a meal of soured milk and oats, while word of her arrival was sent to the hall. This meal, which sounds so unpalatable to our modern tastes, would likely have been a kind of rough curd, thickened with oats, a staple of working people.

Hair cut short and described as dressed in men's clothes, the young queen has gone down in history as being in disguise. It is often said that she was only recognisable by her height. Perhaps this is so, but, as to her hair it could have been cut because she had recently miscarried, or so her history says. As to her clothes, it was common for border women to ride booted and breached, especially when riding over rough country. It was a matter of practicality, as side saddle or pillion was for social occasions or church. This necessity could have stood her in good stead, but regardless of any apparent alteration in her appearance, she appears to have been recognised.

I admit to often thinking of her as an exhausted young woman, playing a bloody political game in which she herself is a major pawn, seeking help and shelter. There are a few certain facts that we have concerning Mary, one of them being that she did stay at Workington Hall. Whether she travelled there from the shore by foot or by horse, by the north or south ridge above the river, we will never know: the base of both ridges would very probably still have been tidal marsh.

While at Workington Hall the young queen wrote one of the most famous letters in British history, begging her cousin Queen Elizabeth for shelter, protection and help. She left Workington Hall under the 'protective' custody of Lord Lowther, being taken first to the house of a merchant named Fletcher in Cockermouth, and then on to Carlisle Castle. It is natural to wonder how she must have felt, gazing back towards the border, towards a country from which she had barely escaped with her life.

The arch that Queen Mary rode through is still part of Workington Hall; she entered a free woman, but what her exact status was when she left is still a matter of debate.

There is an almost certainly apocryphal local story that is worth repeating. It says that the then Lord Curwen was expecting Mary's arrival, and had a plan to marry her to his son. But he got cold feet and was 'not at home' when the young queen arrived.

It is often stated that the men of the Curwen household were absent when the fugitive queen sought refuge, and that Mary and her company were greeted by and received hospitality from the ladies of the house. One poignant story tells of Lady Curwen giving the queen a supply of fresh linen. This tale has always had a practical ring of truth for me, after the flight and trauma of her escape, she could well have been in dire need.

Northside Bridge

The River Derwent has many bridges – foot, rail, road – both historic and relatively new. I have decided to include only the major and most interesting in detail; the others will be acknowledged, but to describe them all would make this a book of bridges which, I suppose could be of interest and value within its own right.

It is a fact that the Derwent Valley has been occupied for many generations, and that the River Derwent has been a major part of day-to-day living for so long that most local people cross it without a thought, taking the ability to cross at will for granted.

The number of bridges, paths and access points says something of the river itself, confirming it as a living part of the community; a vital part of industry, living and leisure. Three bridges serve Workington town and its immediate environs: two road bridges and one footbridge. The new Northside Bridge is sturdy and graceful, and is within weeks of its official opening as I write. The destruction of this bridge's predecessor in the devastating floods of 2009 was responsible for the tragic demise of PC Barker, an event which locals will not readily forget.

The conception of the 'old' or original Northside Bridge was apparently driven by a boundary change that made Northside part of the town of Workington. There had been a stone bridge at Calva, about a mile and a half upstream of the Northside Bridge, since the 1700s, but the building of another road bridge was and has continued be a boon.

Built in the late 1800s this first Northside Bridge was constructed of sandstone, with wide stanchions and separate arches for road and river, the northern end curving down towards the roundabout on the A596 coast road. The new bridge joins this roundabout at virtually the same point. Also, it is directly over the site where local history tells us that the Viking sword, and perhaps more, was discovered.

One thing to keep in mind: the original Northside Bridge was said to be haunted by the figure of a woman, a completely featureless all-black apparition known, not unexpectedly, as the 'Black Shadow'. It will be interesting to see if this phantom turns her attentions to the new bridge.

The Viking Sword

The houses that sat close to the old Northside Bridge between road (A596) and river have long since been demolished, and what was left of their gardens taken by water erosion. Now the site is a popular walk, the beautifully landscaped banks showing the river with its nesting swans to full advantage.

This stretch of the Derwent is tidal, and it is broadly accepted that in the past tidal waters habitually washed up and over both banks, and these areas would have consisted mainly of sandy marsh. During high tides, water on the south side spread across what is now known as the Cloffocks, previously an area of common land and now the site of council offices and car parks, towards the long town ridge with the Georgian houses of Brow Top on its eastern end and St Michael's church overlooking the west. This tract of land still floods periodically. To the base of the Northside Bridge are the oyster banks of the fort of Burrow Walls.

A Roman road – marked on the OS Map of Roman Britain as a 'possible' Roman road – is said to run across this northern ridge; perhaps to keep clear of the tides? Any possible river crossing would, by its nature, have been at river level.

The story of Workington's Viking sword is tantalising. Reputed to have been found on the north side of the river when the stanchions of the original Northside Bridge were being constructed, it should perhaps rightly be called the 'Northside' sword.

This artifact was, and to my own knowledge still is, in private hands. I was fortunate enough to see the sword and the wooden 'coffin' shaped to hold it some years ago when it was part of an exhibition at Workington's Helena Thompson Museum.

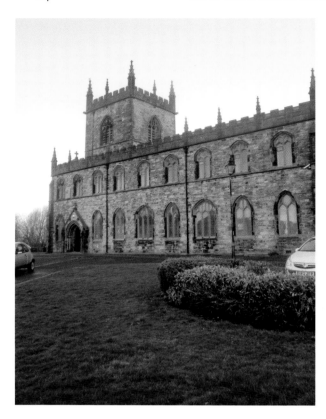

Left: St Michael's church, Workington. At least four previous churches are said to have occupied this worship site, now landlocked, which is associated with St Cuthbert.

Below: The South Gut of Workington Harbour, with the spire of St Michael's beyond the rail viaduct. This church stands at the sea end of the Derwent Valley's south ridge.

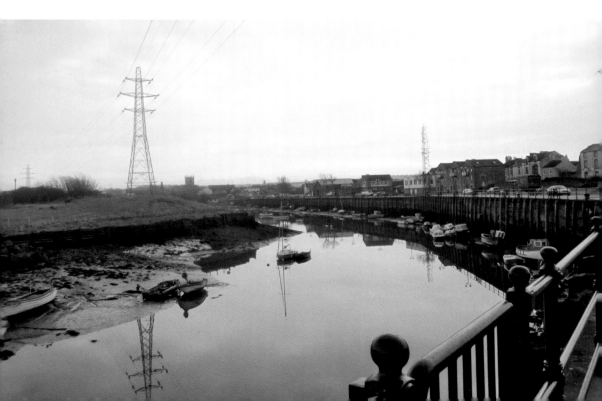

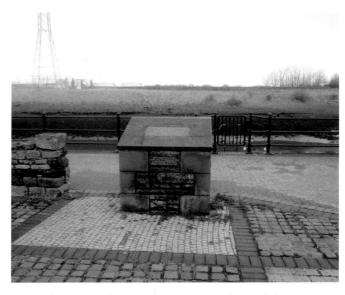

Above left: The 'old' gates of the present church. This side of the mound overlooked the tidal estuary and the mouth of the Derwent.

Above right: The plinth commemorating Mary Queen of Scots' landing in Workington, overlooking the South Gut of the harbour.

Below: Workington Hall stands on the south ridge of the Derwent floodplain, almost in line with Burrow Walls on the north ridge.

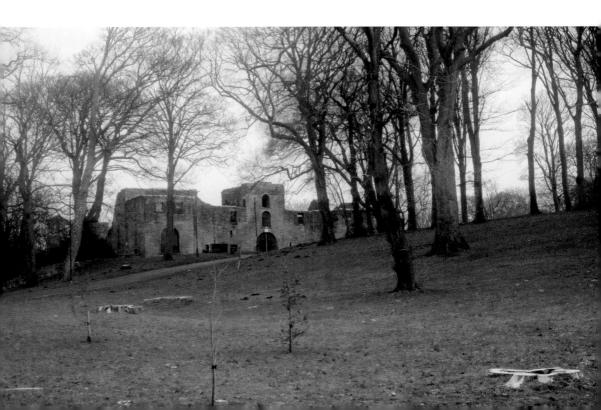

A Viking grave? The grassed area to the right of the picture is said to cover the site where a Viking sword was discovered.

The new Northside Bridge curves gracefully across the river.

The new Navvies Bridge, showing part of Workington on the south ridge.

Downstream from Navvies, swans nest to the left of the bend.

Navvies Bridge from Calva; Lucy Sands' body was found by the road to the right of the picture, close to the stanchions of the old bridge.

The remnants of the mill stream entering the river just below Calva Bridge.

Calva Bridge looking upstream.

Calva: this area is reputedly the site of a Roman ford. The topography has been altered by industry and the railway. The bend upstream of Calva Bridge is also one of the locations where cannonballs have been found.

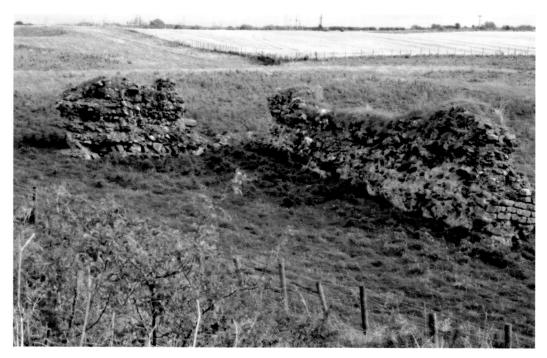

The remnants of Burrow Walls above Calva.

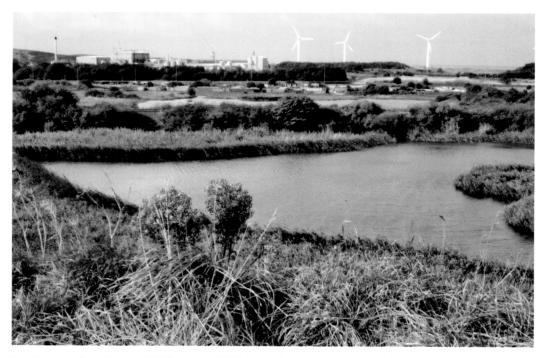

Looking out from Burrow Walls across Siddick Ponds in the direction of the coast.

There is a persistent local story of a body found in conjunction with the sword, and that these remains were buried within the grounds of Northside's Holy Trinity church, which would then have been fairly new. This church does not have an official burying ground, but it would have been a natural and respectful place to inter such a find.

We need to remember that not so long ago, as far as the general public were concerned, little heed other than curiosity was taken over any 'discoveries'. Cumbria is a rich historical area, and finds when building road and rail were relatively common. Also, any discoveries would certainly have been made without benefit of our more modern methods, in the throes of a building site, where hard manual labour would have been the norm, and to lose time would be to lose money.

As mentioned previously, it is a matter of ongoing debate just how wide the river mouth has been at some points in the past. Northside is just south of Siddick, so would it be a very improbable or an over-romantic, if tempting, flight of fancy to think of a Viking burial facing north overlooking the sea.

Tantalisingly, the place that is quoted and widely accepted as the site of the discoveries is now well and truly buried under the stanchions of the new Northside Bridge. So we will never know.

Navvies Bridge

Just upstream of Northside Bridge, the Derwent is spanned by 'Navvies', a footbridge, and a wonderful place from which to watch the river. At this point we are still close enough to the sea to be fully aware of the tide's effect on these lower reaches, and if you know where to look you can sometimes see trout tucked under the banks. Brown trout and some rainbow and white trout are residents of the river. Other residents include a food source for most others – sticklebacks. Minnows are more often found in the smaller side streams.

Migratory fish are first and foremost salmon, and of course eels and lampreys. Most Cumbrians of a certain generation will easily recognise eels; the lampreys are distinguished by having a sucker under their bottom jaw, and are much smaller than eels. I am told that there are now fewer eels in the river, the principle reason behind this said to be a change of course in the Atlantic Conveyer. More unusual migratory visitors are plaice and dabs which have been seen and also caught, as far up river as the Yearl.

Gulls are obviously a common sight on the Derwent, especially here, where we are still relatively close to the sea, but it is amazing how far inland they will go in search of the main chance in the shape of a fine fish. I have been told of them sitting on the banks watching anglers.

The view from Navvies Bridge both upstream and down is worth stopping for and it is an excellent place to watch these fantastic birds wheel and dive with the swans looking on as if they disapprove.

It is somewhat obvious that Navvies Bridge has been literally named for the rail navvies who built the first crossing here. There have, over the years, been three footbridges and a rail bridge on this part of the Derwent. Two previous footbridges have been lost to floods, the last one in 2009.

The rail bridge carried the London, Midland & Scottish Railway (LMSR) line; this was a single line, crossing from Central station, located about half a mile from the river on the

south bank, to Bridge station on the north side. Two points of interest: Bridge station was located near Calva, the oldest surviving road bridge to cross the Derwent, and Central station featured in the film *The Stars Look Down*. For this and all other information concerning railways and rail bridges contained in this book, I acknowledge and thank friend and fellow author Derek Woodruff.

Derek also told me of a near disaster in 1944, when a munitions train on the Royal Naval Armaments Depot (RNAD) line ran away on an incline. The signalman at Calva junction managed to divert the runaway away from buffers to the main line, where it came to rest safely over the river on the unoccupied line of Navvies Bridge.

The stone stanchions of one of the previous bridges (probably the rail bridge) were only cleared when the current bridge was being built. This new Navvies is a graceful suspension bridge, well used, as were its predecessors. This bridge connects the north side estates with the centre of town. The extended path on the town side utilises part of the old rail bank. There is also a well-marked cycle path taking you towards the cycle routes on the Derwent's northern ridge.

On the left bank (the left side going upstream), somewhere around the footings of this present bridge, the body of a young girl was found hidden beneath a pile of road menders stones. The body was that of one Lucy Sands and her murder led to a notorious murder case early in the previous century. It was a case that in many opinions was never satisfactorily concluded. Black Path and the Workington cricket ground lie directly on the right, and a just few yards upriver is the old pump house that served the towns steel industry for so many years.

Calva Bridge

Calva Bridge, sometimes called Workington or Hall Park Bridge, is a few hundred yards upstream from Navvies. A footpath from the north of Navvies leads along a broad grass bank, splitting right at Calva to the main coast road (A596), and left under the bridge, still following the Derwent's bank towards Barepot. From here on you begin to see many more herons; for some reason they are not very common in the lower part of the river. Although I often think that the reason for the birds' interest in this area can be summed up in two words: anglers and fish.

The structure itself, a three-arched stone bridge, is listed, and deservedly so. Built in 1841 by Milton & Nelson of Carlisle, there is a stone plaque to that effect built into the upstream road side wall: 'Workington Bridge built AD 1841. Thomas Milton Civil Engineer. Thomas Nelson Builder.'

Water seen entering the river on the right downstream side is the remnant of the old Hall Park Mill stream, which is diverted via a sluice gate from the main river just beyond the Yearl. After passing the mill, this stream crosses both the Mill Field and Hall Park, to be directed by sluices partly into the main river, with the remainder becoming part of the Laundry beck, and then the Cloffocks beck, before finally joining the sea at the South Gut. This would also probably have been the water feed for the now closed Workington Brewery.

Calva, Workington, or Hall Park Bridge is the third known to have occupied this approximate site. I am certain that this crossing has, at varying periods, been known by differing names, all being appropriate to its position and local area. The most accepted present name is Calva. Interestingly, this happens to be where the old St Calva farm sits on the hill overlooking the bridge from the north, and Calva translates as 'Hill of the Calves'.

There was a stone bridge close to this crossing point in the 1700s, and before that a wooden bridge, although this was probably not the first. There was a Roman ford here, so it is believed, when the river was wider in its bed and before the banks upstream of this present crossing site were strengthened by stone walling. It is more than likely the river was fordable here, especially at low tide. The Romans were probably neither the first or last to ford the Derwent at or around this point.

Folklore concerning a Roman bridge is less tangible, although the remnants of Burrow Walls, which lies on Calva Farmland, to the right of the cycle path leading from Navvies Bridge, does have the remains of a Roman fort beneath. Also, there is a Roman road along this part of the north ridge, which is believed to join the accepted road line from Papcastle to Maryport. From Derventio to Alavna, this information and spelling are shown on the OS Roman Map of Britain.

Burrow Walls

Burrow Walls is easily spotted from the river; the stone ruins sit prominently on the north ridge, and it is obvious that any substantial building occupying this site would at one time have been visible from both sides of this ridge, and would have had an unobstructed view over the sea and river mouth. Despite the passage of time, it is clear that this site is a perfect location from which to guard the river as it begins sweeping inland, and that any sizeable structure on this location must have been visible from the sea. This area on which the remnant of Burrow Walls stands is locally called the 'Oyster Banks', and has been so named for as long as anyone can remember.

The remnants of stonework visible here today are said to still have some Roman blocks incorporated, and the visible remnants themselves are medieval. The principal family of this area were the House of Curwen, and Burrow Walls was their first known home in Workington. In the early twelfth century the Curwens moved across the valley to the south ridge, building a fortified tower which is still part of the now-ruined Workington Hall. The family gifted the hall to Workington in the 1900s.

Burrow Walls appears to have been abandoned when the Curwens moved across the river. There is a great deal of local folklore giving possible reasons for their move. One of the most persistent is that they were raided and partly burnt out. This was not an unusual occurrence in what at that time would have been regarded as border land. However, what is visible of the present ruins certainly show none off the obvious signs of burn marks or split stones etc. So much stone has gone, probably to the usual reuses, buildings, and walls, that there is little possible evidence left on which to base any firm conclusion.

Reuse of dressed stone, while it can prove frustrating to researchers, has to be applauded for its utter practicality, and it can lead to unexpected gems in unexpected places. There are wonderfully worked stones supporting gates and walls in many parts of Cumbria.

Another local story of Burrow Walls tells us that this was Seaton Castle. Seaton is now a sizable village set on the high moor between the Derwent Valley and the sea, and in its past it certainly had the status and history to command a castle. However, as far as I am aware there is no solid evidence linking such a structure with Burrow Walls.

The wonderful Herbert and Mary Jackson tell us that workmen employed by the owner of Seaton Mill, a Mr Jackson, found human skeletons and Roman altars among other discoveries at Burrow Walls in 1852. I have not, to date, been able to discover what happened to these finds.

A little over a hundred years later, Burrow Walls was again the site of an excavation, this time well planned and of a somewhat more scientific and skilful nature. R. L. Bellhouse, Iain McIvor and Brian Blake, with students and volunteers, dug here over Easter 1955, with the full permission and support of the landowner, Mr Tom Mitchell. The late Mr Mitchell was himself, a well-known local figure and historian.

It would appear that Burrow Walls was suspected to be the site of a Roman 'fortlet'. In his excellent book *The Solway Firth*, published in 1955, Brian Blake writes that when planning this dig, history of the site 'gave hints of a much larger structure'. Later in the same book, he also tells us that there was a fort '290 feet across the ramparts of the coastal axis and perhaps 360 feet at right angles to the coast'. Apparently part of it had been eroded by an old tributary of the Derwent.

Barepot

It is just upstream of Calva that you really begin to become aware of the Derwent's speed and power, the tide's effect is still discernible at this point, and except in the driest of weather, the river here is relatively shallow, swift and foaming, or fast and deep. Islands of earth and rock collect broken branches and other debris in the centre of the flow, and these havens are usually populated by hopeful birds.

Well-built stone walls support the river's left bank here, and there is a good wide grass pathway at the water's edge. This path is separated from the Barepot road by a low stone wall. The path did continue along the riverside and then left up to the ridge top and the village of Seaton; however a large chunk was washed away in the recent flood, leaving it necessary to cut through Barepot to gain the ridge. On the right-hand bank lie the broad meadows of Mill Field and Hall Park. Here and for several miles upriver, your eyes tell you that you are on natural flood plain.

The meaning of 'Barepot' can be a little obscure, and ranges from a moss or peat hole (from which peats have been dug), to a pool in the river, which makes sense given the location. In Cumbria 'pot' is generally taken to mean a deep hole of cavity, especially in the bed of a river. To cause more confusion, locally the name is often said to quite literally mean 'bear pit', or that it is a corruption of 'Beerpot'.

Modern Barepot is a pleasant collection of houses of varying age and styles, and it is not easy to imagine it as the location of Workington's first blast furnace. It was around 1763 that Barepot became the site of the town's first ironworks. Somewhat confusingly Jollie's 1811 Directory calls this plant 'Seaton' ironworks.

The flat riverbank, with access to plentiful running water, must have made it an ideal location for such an enterprise. It is believed that the first blast furnace was fuelled by charcoal, which sounds an odd choice in an area so rich in coal, although it is possible that there could have been some early local difficulty in producing coke.

Residents of Barepot pre-Second World War. (Courtesy of Mr and Mrs McCleary)

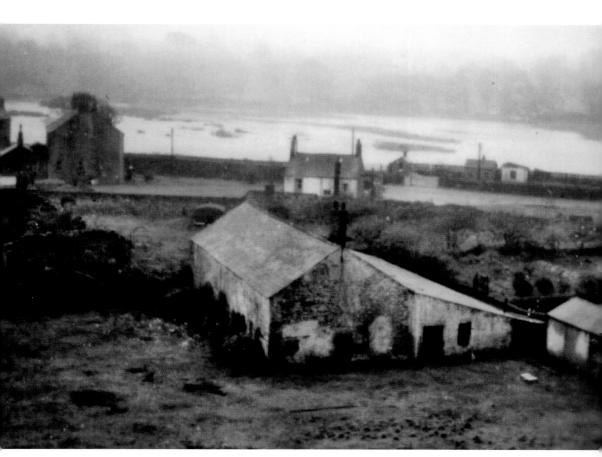

Remnants of Barepot Works. (Courtesy of Mr and Mrs McCleary)

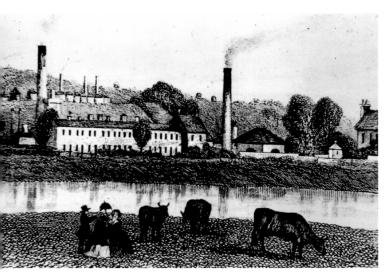

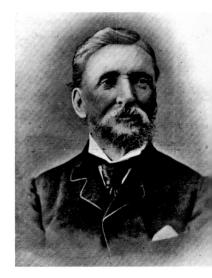

Above left: A print of Barepot in its heyday. (Courtesy of Mr and Mrs McCleary)

Above right: Ironmaster and festival founder Ivander Griffiths. (Courtesy of Mr and Mrs McCleary)

Below: The new chapel. (Courtesy of Mr and Mrs McCleary)

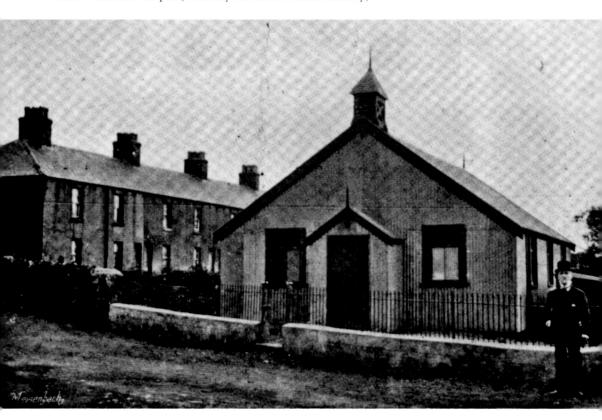

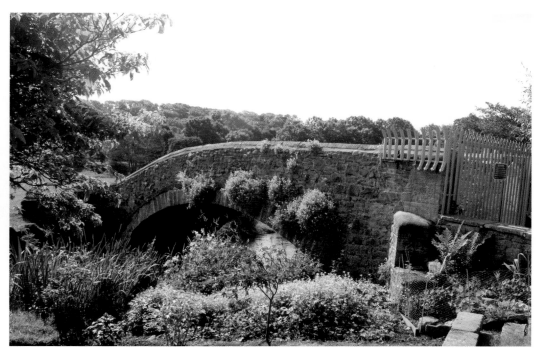

Above and below: Part of the beautiful gardens of Salmon Hall, and the private gated bridge over the La-al Derwent.

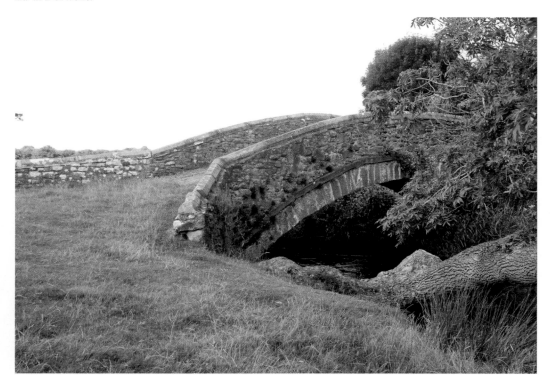

Above left: The La-al Derwent, taken from the bridge.

Above right: Priests Field, close to Salmon Hall.

Below: 'The Old Smoke House'.

Remnants of old fish traps.

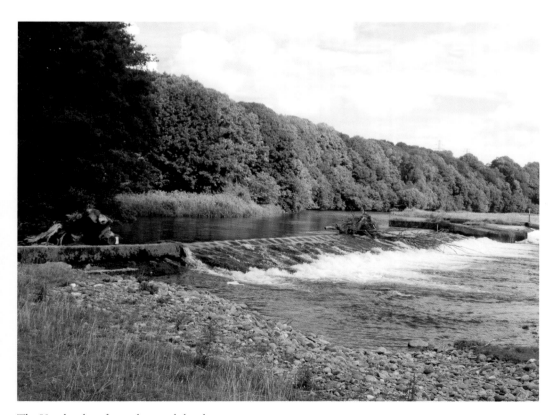

The Yearl, taken from the north bank.

Successful iron production was to grow and continue here under varying companies, owners and ironmasters over the years, as casting, tin plate and other industries were added to the local manufacturing base.

There was a cannon works at Barepot, and it is said that they would test fire across the water deliberately aiming into the sides of the south bank. There are many local stories of cannonballs being washed into the river when the Derwent was high and the weather stormy. Cannon and cannonballs for Trafalgar were produced here. Yet another 'claim to fame' for this area is the manufacture of parts for Stephenson's rocket.

In 1869 a Mr William Evandor Griffiths of Abervon formed a company to buy the Derwent Tinplate Works and, with the arrival of Mr Griffiths, music joined manufacture. Workers and their families, mainly from South Wales, came north to work for Griffiths. These men and their dependants were said to come chiefly from Gwent or Monmouthshire, and were Welsh speakers with very little English. Very aware of how isolated they might feel, Griffiths did his best to bring some of the life of their home country to this corner of Cumbria.

Being of musical disposition, William Griffiths (Ivander) purchased an old carpenter's shop and turned this into a chapel and meeting place, at the same time forming mixed and male voice choirs and a brass band.

The Ivander Eisteddifod, the first Eisteddifod to be held outside Wales, was held at this chapel venue on New Years' Day, 1872. This 'festival of musical competition' was so successful that another was held in the following year. Success bred success, and the festival quickly began to attract audience and competitors from a wider area, necessitating a move across the river to larger premises; first to Good Templar Hall (Duke Street Mission) and then with audiences still growing, on to the Jubilee Hall (now the Opera House) in Workington.

So the festival continued to grow, becoming the Cumberland Musical Festival and Ivandar Eisteddifod. All such activities naturally ceased during the First World War, after which a new committee was formed and the festival was renamed Workington Musical Festival. Other towns were by now following Workington's success and starting their own festivals. With the exception of a natural break for the Second World War, 'Workington Festival' continues to the present day, having been extended to include a highly successful dance section, which itself is now some thirty-eight years old.

With an impressive list of trophies and famous competitors, Gold Cup winners include Kathleen Ferrier (Wilson). Workington has every right to claim that it is the oldest musical festival and the first Eisteddifod in England.

In more recent years there was a popular model yacht club at Barepot, which is now sadly non-existent.

Salmon

I would like to say that any understanding of angling and fish that I appear to show is due to the help of Tony Harrop, who has been generous enough to share his knowledge and experience of both fish and the river.

To think of Cumbria's River Derwent is to think of the 'king' of fish – the Salmon. This length of river from Calva Bridge through Barepot to the Yearl is a good place to observe both anglers and fish, if your timing is right. It also has the advantage of being a public footpath on the Mill Field side; the footpath on the Barepot side is now incomplete.

First of all a few facts, which do much to demonstrate not just how well organised and controlled the sport is, but also how responsible, aware and conscious of their environment and the health of the river the owners, anglers, their clubs and associations are.

The river is divided into stretches; these stretches are divided into beats or pools. Length of beats can and do vary.

The principal owner of fishing rights on the River Derwent is the Castle Fisheries of Cockermouth, in the person of the Dowager Lady Egremont. There are some stretches in other private hands, and there are also clubs, associations and syndicates who own stretches.

Each of these associations and syndicates are responsible for the river banks on their own beats. Clearing them of weed and obstacles, they are allowed to clear branches and trees that have entered the water, but are not allowed to cut standing trees without applying for and receiving permission from English Nature.

In 1996, in response to the serious decline in salmon and sea-trout fishing within the River Derwent system, under the leadership of the late Stan Payne MBE, the clubs, associations and syndicates formed the Derwent Owners Association. The Derwent Owners objectives are:

> To represent the riparian owners on the River Derwent (Cumbria) system in the protection, maintenance and, where possible, the improvement of the fisheries and their associated environment in the River Derwent catchment area. To co-operate and work in partnership with other organisations which have similar aims of environmental protection or the improvement of sporting fishing for salmon or trout to further these aims.

The DOA is actively involved in the River Corridor Group of the Bassenthwaite Lake Restoration project; they also have associations with Natural England, EA, Lake District National Park Authority, Cumbrian Probation Service, West Cumbrian Rivers Trust and other volunteer groups.

Some of the associations and clubs that fish the Derwent have a long history. The Workington Anglers Association has been in existence since 1906, renting the water from the sea to Carr Meadow Bridge from Castle Fisheries. In the past there was licensed netting from offshore boats at high water, in an area just off the coast of Lowca Lonnin, a little upcoast of Workington Docks. These licences were bought out in 2000 by the DOA, so this practice of offshore netting has now ceased.

To call the Derwent a fine salmon river has to be an understatement of some proportion. The season for Salmon begins on 1 February lasting until 31 October. No salmon are taken before 16 June, the main run usually beginning in July.

Female, or hen fish, have a round, smooth head, and I think that most people would recognise a cock fish with its distinctive hooked bottom jaw. This hook is apparently called a 'kype' and has a point which fits into a gap on the fish's top jaw. Early fish are

bright silver, but as autumn arrives it is possible to see silver, orange and red-coloured fish.

When the river is low, Salmon are taken with fly only, on a rising river; spin and artificial lures can be used. But the river can also be a 'big dirty beck', which is a wonderful Cumbrian expression and just what the river can be a great deal of the time. High, rushing and brown with peat and soil, a big, dirty beck describes the Derwent exactly. At such times the fish can be taken with worm.

To see the river in such conditions gives me pause to wonder at the power of the fish able to fight upstream against such a torrent. But I am told that the fish are wiser than that, and when the water is high and trees, gravel, silt and rubbish are being pushed down, the fish will travel slowly up the edges, keeping well away from the debris. When the river eases, away they go and it is possible to see them go over the Yearl weir.

The Yearl

The Yearl was originally constructed as part of the engineering requirement to enable the towns steel industry to take water from the Derwent. The pumping station between Navvies and Calva Bridge was part of the same facility.

The Yearl lies just above Barepot, stretching slightly upstream towards Seaton Mill and Salmon Hall. Beautiful, deep and dangerous, this part of the river was called the Yearl long before the weir that has become known as the Yearl was constructed. This weir consists of a long wall of concrete, its convex side facing downstream, forming a deep pool the width of the river behind it.

On the south side of the river above this pool, the banks are precipitous and heavily wooded. It is here the Yearl Steps descend steeply from Stainburn Road at the top of the ridge, to a path leading past the sluice gates, across the mill stream via a small gated bridge, then over Mill Field to join the river's edge. This pleasant and popular walk is well known to generations of local couples. The mill itself, sitting between the meadows of Mill Field and Hall Park, is now both picturesque and purely residential.

Sadly there have been a number of deaths in this part of the river, not all of them accidental. The Yearl is also one of a number stretches of the Derwent that is persistently claimed to be haunted. It is hardly surprising to find such stories part of the folklore of almost any location that has been known used and seen so much tragedy across many generations.

A 'Grey Lady' drifts down the bank from the direction of Workington Hall, floating across the meadows to disappear close to the Yearl. This apparition, according to local reports, has been seen regularly. But the most repeated and often experienced stories, including contemporary accounts, involving this stretch of the river as far upstream as Brigham (about 5 miles) are all of monks. This is hardly surprising taking into account the ecclesiastical and monastic historical associations of the Derwent, still remembered in names like Abbots Wood, Monks Wood and various 'Cross' sites.

Workington's principal local family, the Curwens of Workington Hall, have well recorded association with both Church and monastic orders within Cumbria.

Seaton Mill

Now beautifully renovated, the Seaton Mill buildings have been turned into living accommodation. Originating pre-1850, Seaton Mill is a Grade II listed building sitting beside the riverside path just upstream of Barepot. A large part of this original path having been lost to the river, the approach to the mill is now either through Barepot or down Seaton Bank. This mill served its local manor of Seaton for generations. Latterly, in common with so many others, the mill wheel has been removed for practical reasons, although the present owner did tell me that he has had the old wheel turning, and that he does own a set of metal paddles.

This is one of the stretches of the Derwent associated with monks in local tales. There are stories of certain abbeys holding fishing rights and even the right to change the course of the river at some periods in history. These tales are embedded in local lore, and some elements do appear to have points of accuracy. 'Fishing rights' in the case of the holy brothers appears to be the right to trap fish in artificial pools, and, I presume, netting them.

There is a mention in *The History of the Ancient House of Curwen* by John F. Curwen, dated 1928, not of fishing or trapping rights but of tithes. Here J. F. Curwen quotes a promise of 'tyths' (pure and perpetual alms) to be paid in salmon by one Patrick, son of Thomas, and his heirs, to the Prior and Monks of St Bees, amounting to fourteen fish per year. He also appears to have granted fourteen fish to monks at the cell of St Bega in 'Coupland' (Copeland?). These tithes would have been worth a small fortune in their day. Patrick also leaves a confusing instruction that is part of this promise, stating that the salmon should be 'obtained' from the mill pool 'of Workington'? The year quoted was 1250, the manor of Seaton (and we presume a mill of some sort) was in existence then. At the same time Patrick makes a grant to St Mary's Abbey in York (not in fish).

'Workington Mill pool' is confusing; there is an old mill in Hall Park, always thought to be much later than anything originally in the manor of Seaton. Perhaps it is just too easy to read too much into something that is not as confusing as it looks … Or was there another set of old 'traps' on an entirely different part of the river?

The existing buildings of Seaton Mill and Salmon Hall do not, at first glance, appear as old as their apparent history. It is far from easy trying to untangle the embedded folklore of generations, and I truly believe that when you come across such persistent myth, there is some truth in it somewhere – not everything gets written down. The 'myth' in this instance? That monks lived and trapped fish on this part of the river, on and above Seaton Mill.

I have a lifelong angler to thank for the following information, although I believe that it is commonly known. The right to trap salmon in pools on this stretch of river was held by an order of monks in the twelfth and thirteenth century, and a condition of this right allowed for these traps to be opened every Friday, allowing some fish upstream to spawn. This right passed on to subsequent owners of the fishing rights and was still in force in the 1960s, when it was broken by an Act of Parliament.

Salmon Hall

There are old fish traps in the Derwent, possibly still over or near roughly the same sites of even older traps; all the associations connected with these appear to centre on the area of Seaton Mill and Salmon Hall. It is more than possible that these lovely period buildings could be on or close to the remnants of much older constructions. Perhaps some holy brothers did once live 'on site'?

According to those supreme researchers, Herbert and Mary Jackson, Salmon Hall was so called because any owner or occupier held the fisheries. They also state that Salmon Hall was once owned by the Earl of Lonsdale.

There is a picture of Salmon Hall showing a farmstead of around 1700, parts of which are still recognisable in the fine set of buildings that are still there today. The original house was converted into cottages in the '60s; the remodelled and renovated stables and other outbuildings are set in a beautifully landscaped garden on the edge of the 'La-al Derwent', a tributary of the main stream which rejoins the river after circumnavigating a meadow and passing under a fine, old stone bridge next to the main house.

Overlooking this bridge is an old smoke house. Once a vital part of the activity and industry of the river the smoke house has been recently renovated and this attractive building now serves as a store and summer house overlooking the water. There are the remnants of two sets of rough stone fish coups among the undergrowth, and fallen trees on the edge of the 'La-al Derwent' in an area that appears to have the ability to become an island when the water is 'right'. The two sets of abandoned traps speak of a changing water course.

Trapped fish were taken with nets and brought by rowing boat to 'Priests Field', on the water's edge just downstream of Salmon Halls Bridge. Here the fish were landed and prepared for smoking. The 'Priest' in Priests Field is not, in this instance, thought to be a remnant of association with monks that may or may not have been in this area, but of the heavy wooden club used to kill fish. When the salmon were landed it is more than likely that some would still be alive, and so the 'priest' would be used.

The meadows and river banks around Salmon Hall are a nature lover's joy, the environment attracting kingfishers, otters and nesting swans just to name some of the creatures who thrive in this habitat. The area has been awarded HLS (Higher Level Stewardship) status.

Alongside a wonderful variety of native plants there are also picturesque clumps of the lovely pink balsam here, as along most of the Derwent's length. These gorgeous orchid-like flowers are kept well under control and not allowed to threaten native flora. I was fascinated to be told that the weed produces pollen that makes delicious honey. I suppose that most things have an upside, even this lovely menace. It somehow feels wrong that something so beautiful can be all bad.

Dr Peat, a famous local surgeon, was for a time resident in Salmon Hall and, I am told, swam in the river here each morning, from the fish coups to the bridge. Dr Peat has the distinction of having a monument raised to him in Workington's Portland Square, in memory of his work and dedication to his fellow men. This memorial was raised entirely by public subscription.

The doctor worked tirelessly with and for the poor and unfortunate of the area, especially through devastating epidemics. It is commonly believed that he worked himself

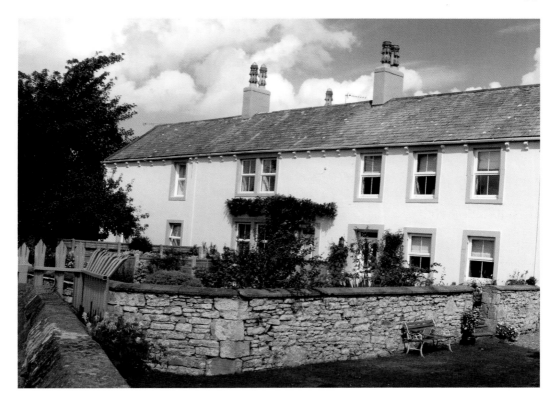

Salmon Hall.

to death. These epidemics and other threats to public health were eventually removed by a breakthrough water filtration scheme in which the Derwent played a key roll.

Water

Cholera and Typhoid are nightmare words that were all too familiar to our not-so-distant ancestors. We are all now familiar with the causes of these virulent killer diseases, bad sanitation and ingestion of faeces. In common with so many other towns and cities of the past, Workington's sanitation arrangements and the general population's access to clean drinking water left a great deal to be desired. As well as the town's own sanitation ranging from bad to nonexistent for most of its population, Workington also suffered from its geographical placing as the last population centre before the river mouth. There were, and still are, a few springs and wells within the town boundary – Friars Well being one famous local example – but it was the river that was regarded as the main supply of water for all domestic, and also some business purposes, including the disposal of sewage. Workington was not only polluted by its own waste, but also by the waste from Cockermouth, and a number of villages a few miles upstream, whose general sanitary arrangements appeared to be exactly similar.

After several particularly bad outbreaks of disease, and the realisation of the population's growth with the expansion of industry, it was decided that something had to be done, the problem had to be addressed. Planning, negotiations and ideas on how and what would lead to a satisfactory scheme could almost make a book in themselves. However, eventually a joint venture involving Workington and Cockermouth was proposed and agreed upon. This scheme, a leader in its time, involved taking water from Crummock Lake, and in Workington's case, the building of a large, clean, water reservoir at Stainburn high above the Derwent on the south ridge, just to the left of the (now) old A66 on the outskirts of the town.

Since its inception in 1879, with further alteration and expansion driven by continued changes in population and expansion of industry, this innovative scheme has proved the ancestor of the water supply enjoyed by Workington and Cockermouth to the present day.

Camerton Church

Above the weirs upstream of Salmon Hall the river snakes towards Camerton and its beautiful church. This church lies at the end of an ancient corpse road that extends to the coast.

The first impression you get of Camerton church is that it is loved, cared for and well used. In the devastation left behind by the floods of 2009, alongside other major problems, the road to this wonderful old church had been washed away, leaving no access and Camerton's church of St Peter threatened with the removal of its roof and subsequent closure. It was through the sheer will and determination of its supporters, volunteers and friends that St Peter's reopened in the summer of 2011.

Camerton church and its named village sit on the north side of the Derwent. The church itself stands beside a sharp bend in the river, and the river actually loops around the church site. I have heard it postulated that at some time in its past the worship site on which the building stands could have been an island.

In the aftermath of flood it was all too easy to give credence to this possibility, as 20 yards of churchyard were washed away and it took 800 tons of stone to repair and strengthen the banks around the church land. In all, 850 sprigs of cedar have also been planted to replace the stone wall that previously completely ringed the entire site. All in all at the height of the 2009 flood, this part of the River Derwent rose by 15 feet. Miraculously it didn't enter the church building itself.

There are some churches in Cumbria that 'by repute' are on sites that date to around AD 600 or earlier. There is no way of proving, or indeed disproving this except perhaps by digging, which might or might not prove conclusive.

It would be difficult to believe that there were not any Christians left here in the aftermath of Roman rule. Local lore tells us that monks from Whithorn and Ireland travelled across Cumbria bringing their form of Celtic Christianity to the northern peoples, and also that these preachers were welcomed in some communities.

It is speculated and accepted by some that parties of these early monks travelled upriver and set up preaching crosses as focus and gathering places for the local population. In time more permanent structures were built on these cross sites, and it is believed that some of these could have survived through many alterations and rebuilds to become, over time,

the riverside churches we know today. It is possible that some sites were special before the preaching monks crossed the Solway. There are at least two churches that appear to be in the remnants of 'Oak Groves'.

Camerton has an excellent leaflet setting out the main history of St Peter's, and it is from this that I have (with permission) obtained the following brief and simplified timeline of this church's known history. The full leaflet is well worth obtaining.

It is thought that there was a stone building here by around AD 1000. Little is recorded before the 1100s when the manor of Camerton was given with others – Seaton, Flimby and Greysouthern – as a wedding gift to Gunilda, wife of Gospatrick, first Lord of Workington.

In 1169 Gospatric gave the living of Camerton to his fifth son, Adam. This is confirmed by the roll of past incumbent within the present church.

In 1179 Gospatic gave Camerton church to the priory of Carlisle. The leaflet tells us that the 'monastery enjoyed the tithes, with some inferior member of the convent supplying the cure'.

The Reformation reached Camerton when Henry VIII gave the rectory and advowson to the Dean and chapter of Carlisle in 1542.

The church was rebuilt in 1794 with further restoration in 1855 when the tower and spire were added, and a new bell purchased.

The three-decker pulpit and old seating were removed in 1892, leaving St Peter's much as we see it today, with a simple and beautiful interior. Inside there is an impressive list of incumbents, and close by there is an ancient water stoop that has somehow managed to survive the Restoration and has been set into a niche to the left of the door by which you enter. Face the altar and, on the right-hand side, just in front of the pulpit, is the impressive effigy of Black Tom, sometimes called 'Black Tom of the North'.

A historical Black Tom Curwen is recorded as accused, with two others, one of these being his son, of the murder of one Thomas Dykes. Taken to law by the grieving widow the miscreants appear to have escaped with a fine, and a promise to pay for prayers for the soul of the departed. This was a relatively light sentence, which prompts some local commentators to believe that the dispatching of Thomas Dykes was all part of an ongoing family feud. Not unusual either at that time or in within the local area.

The legendary Black Tom is said to have been many things, ranging from a kind of Robin Hood to a kidnapper and renowned border warrior and reaver. The effigy's armour dates to around 1500, so he could have been all or either.

Stories of Black Tom are well known and legion. His effigy is said to have originally lain outside the church, the building being extended around it during a restoration. Other tales tell of the effigy being moved but his actual grave and resting place left outside, and although still in hallowed ground, Tom walks looking for his effigy.

One wonderful story tells of a local girl who came in the dead of night and stole Tom's nose for a wager, and that this desecration was the reason that Tom's effigy was moved. His nose is missing, and she must have been a brave lass, for beautiful as Camerton churchyard is, I would not like to be alone there at night.

It is unclear exactly where in the shelter of Camerton's peaceful churchyard the infamous Tom lies, but there is one member of a famous family whose resting place, although well marked, is surprisingly little known. It is the grave of Arron Wedgwood, who was a member of the Ripton branch of this famous pottery family and lived there before moving to Staffordshire.

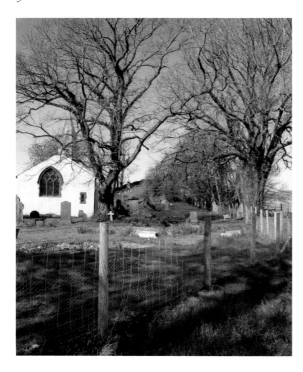

Left: Camerton church. The new fence to the right marks the edge of the riverbank.

Below: The view beyond the fence, showing some of the debris left by the floods.

Opposite above: Part of the wrecked churchyard wall.

Opposite below: Primroses against grave slabs.

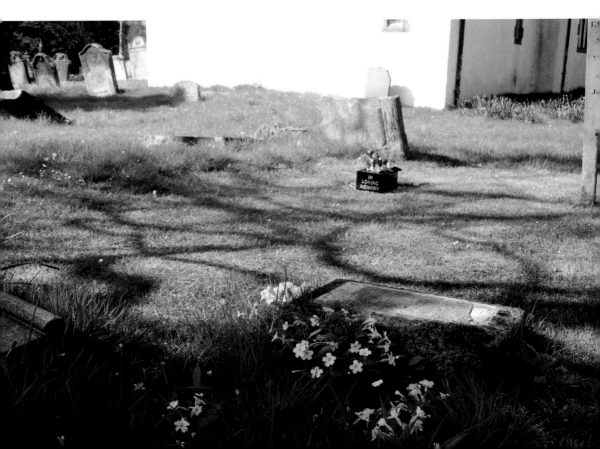

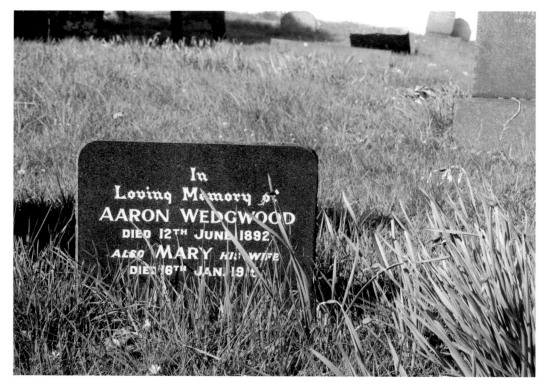

The Potters' grave.

Looking from Camerton church across the river curve towards Clifton Banks.

There is a good supply of differing types of clay in various locations within the immediate area, and potteries are known to have existed at both Camerton and the village of Clifton, which is located just a short distance upriver, and there were possibly other manufacturing sites that we no longer know of.

It is also true that there is relatively little knowledge or detail left of any potteries that we are aware of, but it is tempting to speculate that perhaps a member of the Wedgwood family may have practiced his skills close to here. Potteries are just another almost-forgotten example of the diversity of industry in proximity of the Derwent.

Camerton is a difficult word from which to draw meaning. The ton, 'tun', is common and can designate anything from a town, farmstead, group of dwellings, to a single dwelling or personal place. Roughly the older the usage, the more likely it is that it refers to a smaller group or single dwelling. But this does not always hold true. The prefix 'Cam' is said to have some sort of personal meaning.

When I was a child I believed that the stretch of the Derwent encompassing Camerton, Bow Flats and Clifton was one of the fastest stretches of the river, and there were whirlpools there. If this is, was or ever has been true, I have honestly no idea, but it was enough for my childish imagination.

Clifton

The name Clifton means something like 'enclosure by or on the cliffs'. There are steep banks above part of the river where it sweeps close to the village. Both these and some of the higher banks around Camerton are said to have some ancient man-made terracing, and there is a suggestion that Iron Age people once lived above the river in this area. This has been postulated for some years and I believe that there was some amateur exploratory work done here between the wars. It would have been a good choice for such a settlement, being close to fish, game, water and fuel.

There is also some suggestion of primitive smelting here, in common with so many other areas in West Cumbria. It is only two or three generations since primitive iron hearths were generally either ignored or ploughed up, depending on their location. Now of course it is a very different matter, the value of such finds is recognised and known sites usually protected.

The present Clifton developed chiefly as a mining and farming community, like so many others the pit closed some years ago. Now it is a sizeable village with a pleasant mixture of old and new houses. Interestingly, in the centre of 'Little Clifton' there is an open space named the 'Pow', which is an ancient name for meeting place and gives cause to wonder just how old the original village settlement could be.

The Clifton Dish

One wonderful example of Clifton pottery survives in the Helena Thompson Museum in Workington. This example is a superb 'Wedding Dish' about 20 inches in diameter and

complete with the initials E. M. Made of cream and brown slipware, this dish also carries a so far unidentifiable crest, with a lion to the left and unicorn to the right of the central decoration. The whole is surmounted by a crown, not unlike an example of King Edward's crown. I am in no way suggesting a royal connection, but there was apparently quite a fashion in mock crests and if you could tie it to some vague family interest (farming or hunting) all the better; you were one up on your neighbours.

Sadly, we have no idea who this lovely dish was made for. 'The Clifton Dish' is scrawled on the blue-grey back and the date is thought to be seventeenth/eighteenth century.

The Marron Junction

The River Marron enters the Derwent on the south side, upstream of Clifton. Obviously and specifically named the Marron Junction, this was a famous three-way rail junction, where the line from Branthwait joined the Workington, Cockermouth, Keswick, and Penrith main line.

There were five bridges on this particular section of the main line; I was told one for every bend in the river that this spectacular and pretty rail route crossed and recrossed. (What a tourist attraction it would be now.)

Apparently all the bridges within this section were of a regular pattern being 'arch bow girder bridges'. The Brigham Bridge was closed in 1935, and there was tragedy there when, during its demolition in 1936, there was a sudden collapse, resulting in four workmen being thrown into the river. Sadly, two of the four drowned.

Spawning

The River Marron passes through a deep, wooded gorge on this final stretch of its journey to join the Derwent, and it is at this point that some Derwent salmon leave the main stream and head towards their spawning grounds at Ullock and Branthwait. Some fish spawn within a week of reaching their spawning grounds, others will wait up to three or four months. This natural spread is nature's way of giving the fry a better chance of survival, for these fry have to survive both nature and predators to become smolts before leaving the river, in their first, and for some their last, attempt to head for the open sea and feeding grounds.

Fry have to survive in the streams and rivers of their birth for up to two years before becoming first parr and then smolts, large enough to attempt to leave the river. The hazards within this development period are tremendous, for during this time they are easy prey for numerous fish eating birds, herons, goosanders, mergansers, cormorants, other larger fish and various forms of wildlife.

When the time is right, those smolts that have managed to survive shoal and make a bid to leave the river. At this stage they are about 6 inches long and have gained a silver coat. A 6-inch smolt can put on twenty or thirty times its original weight in its first year at sea. If they return after only twelve months at sea, they will be between 3 and 10 lbs in weight. However, some salmon will stay at sea for two or even three years before returning to spawn for the first time.

The odds against almost any stage of a salmons' survival appear to be phenomenal; if they do make it past their first growth stage and manage to leave the river and reach the sea, the danger is far from over. For every thousand fish that reach the smolt stage, only one or two is likely to survive long enough to return and spawn.

I believed, I suppose as many other people do, that the spent fish die after they have completed spawning. After spawning Salmon are called kelts, and it is true that many will die as they may have lost up to 30 per cent of their body weight. However, if they do manage to make it back to the sea the Atlantic salmon can, if they survive the perils of deep sea netting and other hazards, return to the river of their birth two or three times within their lifespan. It is rare for a fish to make a fourth journey.

Those fish that do successfully return, two times, three, or the rare fourth time make it possible to occasionally see a truly big fish. I am told that some can reach as much as 30–45 lbs. Amazingly, salmon find their way back to their spawning grounds by smell.

The Marron was long known to be the best spawning ground on the River Derwent, but I believe that it was spoiled by opencast mining, and overtaken by St John's in the Vale. Happily, however, the Marron is now making a full recovery.

3

Marron Junction to New Bridge

Here the A66 runs alongside and in sight of most of this section of the river, crossing the Marron Gorge by road bridge, and following, in part, what was the course of the main railway line to the Carlisle–Keswick roundabout on the outskirts of Cockermouth. Just upstream of the Marron junction, the Derwent curves in a broad bend, with a steep bank above it on the A66 side. This is yet another place I was warned to stay away from as a child. Once again, whether or not there were or are whirlpools here I have no idea. Perhaps the stories were just a way of keeping the overcurious away from a particularly fast stretch? It can be deep here and it undercuts the bank. I remember otters here, and I am delighted to say that I have recently been told that the animals are still there and thriving.

Here, once again, the course of the river takes it across what is obviously flood plain, and it is not uncommon to look down from the A66 and see the water spilling across the fields. Looking straight across this part of the valley you can see the hedgerow of the Camerton–Broughton road that runs along the other side. This is a very narrow twisting road, and a wonderful place from which to take photographs, obviously with great care.

On the A66 side is Broughton Cross. Paradoxically Brigham station was at Broughton Cross. The station house is still there, now a private dwelling accessible from the old road. There was also a cross at Broughton Cross, which was reputed to be a remnant of a preaching cross, but it is years since I have heard the story. It could well be resting unidentified in the corner of a local church.

Across the river Great Broughton is visible; there is both 'Great' and 'Little' Broughton, now long grown into one village. The name Broughton could have something to do with 'beck'. While on the A66 side Stony Beck and Stony Beck Lonnin are next, and the A66 road crosses over this lonnin supported by an old rail arch. The Derwent is still in sight as the road comes to Penny Bridge, with Brigham church across the offset junction to the right.

Penny Bridge

Penny Bridge is a fine, old, arched stone bridge, signposted for Broughton (Great and Little). I believe that there are three possible stories concerning the naming of this bridge: firstly, that

it was a toll bridge (the price to cross was one penny). The second is that it was somehow bought or sold for a penny. I'm sure that someone somewhere will put me right; the third story is, I am led to believe, possibly the oldest. There was a toll bridge downstream of the existing Penny Bridge. Much older, this bridge formed some of the meagre income of a couple who lived in a cottage beside the river. This bridge was eventually washed away, so for some years the couple ran a boat-and-rope service at the crossing. They pulled the boat and passengers across hand over hand. Sadly, the rope broke when the river was in full spate and the couple were drowned.

There was said to be an old ford just upriver from Penny Bridge; this was no more than a half remembered story when my father was a child. I had always assumed that Penny Bridge was originally built to replace this, and if the river was high and you had a penny, you and your livestock could cross in safety.

However, in light of the burgeoning Roman finds at Papcastle, just across the river, and the growing realisation of how big the Roman presence may have been in both the Papcastle and Cockermouth areas, I have begun to wonder just how old the local lore concerning this possible ford is.

The situation could be thought similar to Calva Bridge in Workington, the tradition of a ford close to the site of an old bridge; however, in Workington it has always been regarded as a possible site for a 'Roman' ford, while in Brigham it is simply 'old' ford. There is no denying the evidence of Roman occupation in either Papcastle or Workington.

Brigham Church

Brigham church is named after St Bridget, and sits above the A66 to the right of the offset crossroads, the left branch of which crosses Penny Bridge. The village of Brigham is almost a mile away and it is often commented that the name Brigham does incorporate 'Brig' meaning bridge, and in this case, Penny Bridge. It seems odd to name a village for something that is so far away. It has also been pointed out, many times, that the village could have been named after Bridget as in St Bridget, but church and bridge being close together the argument of distance still stands.

Local historian Paul Lishman has an interesting theory that I have a great deal of time for. In the field just across the side road that runs past St Bridget's there are a number of overgrown spoil heaps, said to be the remnants of quarrying. Mr Lishman postulates that some of these 'spoil heaps' could be remnants of buildings, and it is possible that this field could be the site of the original Brigham. I believe that he could well be right.

The wonderful church of St Bridget is older than either the present village or bridge. Seeing it now, dominating a crossroads on the A66, it is difficult to realise that when it was originally built it would have stood high on its mound overlooking the River Derwent. Now a major road and the remnants of a rail embankment replace what would have been a grass slope, and possibly a track at the river's edge.

St Bridget's is another riverside worship site that is reputed to be much older than the present building would suggest. It does stand on a definite mound, and there are suggestions

that there was a nunnery here. Some commentators suggest a 'double house', male and female, which itself could suggest alignment with Celtic Christianity.

Holy wells suggest an even earlier form of worship. It is said that the poet William Wordsworth wrote of a holy well somewhere in the vicinity of St Bridget's. In my experience, local opinion seems to be that in the past there was a either a well head, or a group of stones and clear seeping water, on a bank above the Derwent, close to the church. This apparently was disturbed and covered when the railway embankment was constructed. There has been the suggestion that it is now part of a culvert.

The church that we see today looks Norman, and there are a number of Norman churches in Cumbria, many showing signs of earlier styles and buildings. There is an excellent paper by Mary Markus, 'The South Aisle and Chantry in the Parish Church of St Bridget, Brigham', which sets out in some detail the alterations and embellishments that this particular church has gone through over the years. The elaboration and beauty of parts of the interior, especially the windows, perhaps give pause to wonder if there was something 'special' about this small church in its quiet setting? The paper gives around 1080 as the earliest (we presume stone) building on the Brigham church site.

A note of interest: there is an area of Keswick also called Brigham, and traditionally and historically this area was associated with smelting. In old Cumbrian folklore 'Brig' is one of the names for 'Brighida' the ancient mother goddess of Britain. Among her other aspects, Brig or Brigg, was goddess of smiths and metalworkers.

I have read of smelting at Brigham, as in Brigham/Broughton Cross. Sheer practicality would put such an activity close to running water. Two Brighams, both associated with smelting ... It does leave some room to wonder about the origin of the name? In Cumbria, Brig, Bride, Brighida, Bridget/Brigit and Bega are well and truly enmeshed, as most people who have studied them will tell you.

Papcastle

Sitting on the opposite bank just upriver of St Bridget's is the village of Papcastle. The most commonly known local translation is 'Pippards' Castle, and there is apparently said to be the remnants of a motte in the area. However, both statements are now often disputed.

There are several suggested meanings and derivations in Sedgefield's *The Place names of Cumberland and Westmorland*. The possibility that intrigued me most was the suggestion that it could be from 'papar', or 'priests'.

The Roman name for Papcastle is Derventio. We are told that the Roman name for the Derwent was Derventio Fluvious (River Derwent). Was the fort named for the river, or the river the fort? River names are the oldest names that we have, and the Romans would simply have given their fort/settlement a 'Romanised' version of the nearby river's local name.

It has long been both well known and accepted that there was a Roman presence in and around the area of Papcastle. The possible size and probable importance of this presence recently appears to be exceeding many past expectations.

The devastating floods of 2009 uncovered what the press widely reported as a possible Roman watermill on the banks of the Derwent downstream of New Bridge. How accurate

this was or has since proven to be is difficult to say, but it did prompt both a geophysical survey and a major dig.

This dig has since been extended and is now in its second year, under the leadership of Mark Graham of Grampas Heritage, site director since its inception. I was fortunate enough to be shown round the site recently by Don O'Meara, the environmental officer for Wardell Armstrong. As well as being extensive, the site is impressive and is in the process of interpretation by David Jackson, site supervisor, and also from Wardell Armstrong.

Accessed via a steep lonnin leading down from the village of Papcastle, the excavation sits on the flood plain within yards of the present riverbank. The present opinion is that the line of the Derwent at this point is very close to its position in Roman times.

The site is full of interest – that's an understatement. The proximity and number of possible buildings is fascinating. The remains of substantial, well-built Roman walls are in parts overbuilt by what would appear to be sturdy but much clumsier methods, featuring what looks in parts like a river cobble surface.

This 'overbuild' appears to give no thought to the building beneath, giving the possibility, I was told, that the builders were either unaware of, or gave no thought to, the fact they were building over ruins.

The Roman part of this overbuilt area appears to be a series of small chambers, possibly for storage? Remnants of grain have been found close by. Little else has been discovered in the way of finds, with the exception of a candlestick about a metre high.

In another part of the site there is a partly exposed circular feature, with fine brickwork, possibly part of another building. There is also what was described to me as 'warm rooms', and several areas paved with fine slabs. It is thought that these areas could possibly have had a social function.

There is one building within this area that, in contrast to other parts of the site, appears to have been built over with some preparation and care. The entire site appears fascinating, complicated and ongoing with evidence of it extending downstream.

The possibility of this part of the Derwent having an inlet or harbour for river barges has been put forward. This and other ideas will be investigated in future digs.

There has, in the past, been some difference of opinion as to the line of the Roman road(s) within the area of Papcastle. There is a ramp on the landside of the dig, sloping up a bank between the flood plain and the village, considered by some to be part of a possible Roman road or track. Locally this ramp has been called 'Priest's Path' for generations.Interesting when you consider Sedgefield's suggestion.

New Bridge

Approaching the outskirts of Cockermouth, the Derwent passes under New Bridge, or to be more correct it passes under the A595 from Carlisle as it joins the A66 at the Cockermouth/Keswick/Workington roundabout. I often approach this junction on the A595. This part of the road has height, and the view of the river, as it snakes across the countryside, is magnificent.

Gote Bridge

An old stone road bridge that arches the Derwent on the outskirts of Cockermouth, the Gote Bridge has a rather morbid claim to fame. There is a story that Mr Wilson, the Carlisle hangman, threw himself into the river here in 1757, and that he is buried in Brigham churchyard. Given the date it appears odd for a suicide to be placed in hallowed ground, but the story persists.

Another local tale describes his headstone as being embellished with a hangman's noose carved in stone, but this somewhat morbid decoration fell prey to souvenir hunters.

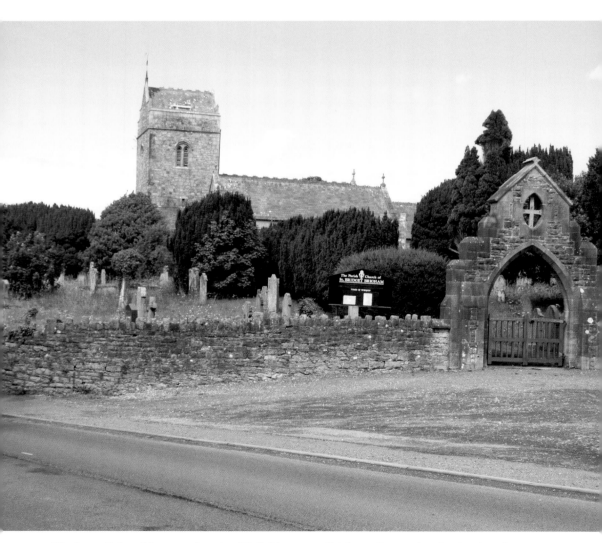

The beautiful and famous church of St Bridget near Brigham. Reputed to be the site of a monastery in the past, the church mound overlooked the Derwent. It now overlooks the A66 and a disused railway embankment.

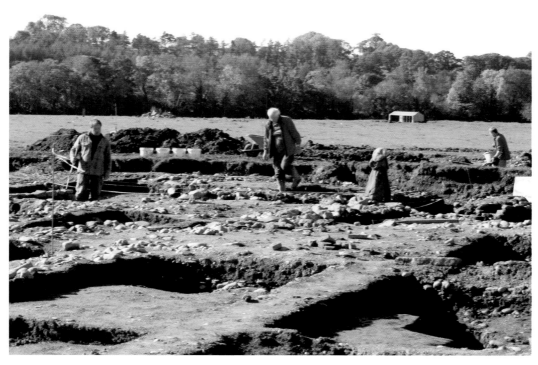

The Papcastle dig, photographs taken with the permission and co-operation of Grampus Heritage.

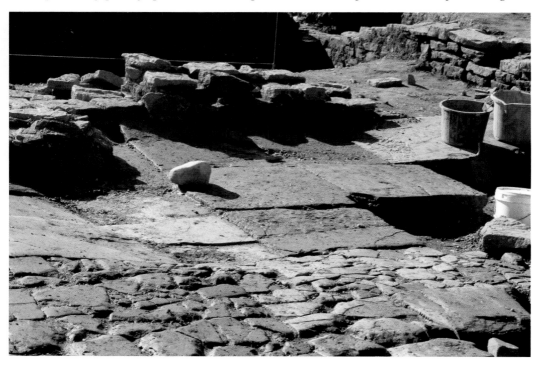

4

Cockermouth to Bassenthwaite

Cockermouth

Cockermouth appears to have grown along and around the water, probably spreading from what is now Castlegate at the base of the Castle mound, and gradually encompassing higher ground as the town expanded, like so many riverside towns that are able to look back on some hundreds of years of history and development. There have been periods of alteration, restoration, building and rebuilding. Today Cockermouth is a pretty, pleasant town with much to recommend it.

The River Cocker runs to Cockermouth, and the River Derwent runs through it, passing under Gote Bridge on its way, and two footbridges. The 'Gote' bridge has officially been the 'Derwent' Bridge since 1820, but it thankfully persists in its older, traditionally preferred local name.

Of the footbridges, the first upstream of Gote Bridge is Millers Bridge. This crosses from Bridge Street across to Millers car park, now a public car park. This bridge was reopened by the Princess Royal in 2010. The second bridge is Brewery Bridge, reopened by the head boy of Derwent School in 1963; this was formerly Waterloo Bridge, which itself replaced Barrel Bridge, a road bridge.

Having developed through several similar forms, the name Cockermouth is entirely descriptive. The mouth of the Cocker spills out to join the Derwent at a river fork which lies below Cockermouth Castle and beside the Castle Brewery. As you would expect, the joining of these two rivers can be spectacular, especially when the water is high.

The town, its location and expansion from its early history onwards has been driven and influenced by waterways. As well as the Cocker and the Derwent rivers, two becks – Bitter Beck and Tom Rudd – have played their part in the town's early industrial development.

Cockermouth sits in an almost ideal location: a valley where two major rivers meet, surrounded by productive farmland and ringed by hills. Looking down on it as you descend from Moota on the A595, it is obvious that it lies, for the most part, in a sheltered dip, and the town can appear almost magical, especially in the half light.

We have some evidence of early settlement and development along the length of the Derwent. The town of Cockermouth and its surrounding area will be no exception. Without dedicated, comprehensive study, we can have no real idea how wide the River Derwent or indeed the Cocker may or may not have been in earlier times. The confluence of these rivers is on a natural flood plain; indeed Cockermouth does and has flooded periodically for most of its known history.

Taking this into account, it is reasonable to suppose that any earlier, possibly pre-Roman settlements would most likely have been on slightly higher ground close to yet above the rivers. The terracing at Camerton is a case in point. Our earlier ancestors seemed much more attuned to natural dangers than we appear to have been, but we are learning.

As mentioned previously, the Romans were in this immediate area around the village of Papcastle, which they called Derventio. Anything that may or may not have been within the boundary of what we now regard as Cockermouth is not shown as having a separate Roman name, according to the OS Map of Roman Britain. Rivers were the trunk roads of the past, and it does not take much imagination to see the joining of two rivers as an ideal place for gatherings or trade, before, during or after Rome.

As ever there is an apparent dearth of provable information in the aftermath of Rome. The Vikings probably passed through here, and the brothers and saints of the 'Old' church. This is, as far as I am aware, educated assumption based partly on knowledge of the River Derwent and its known adjacent worship sites: Brigham and the lovely Isel to name only two.

With the Normans came written information, and their presence is often also shown in worship sites, trying, but not always quite succeeding, in blocking out those who came before. There is a reasonable body of opinion to suggest that a town could have begun here around the time the first castle-like fortifications were being built. Protection attracts.

There is an excellent series of hand-drawn and handwritten books by the late J. Bernard Bradbury, which show much of the early and ongoing development of the town of Cockermouth.

Most of the buildings we see in Cockermouth today are, or appear, Georgian. This was a period when many Cumbrian towns seem to have expanded developed and prospered, and this market town with its wonderful Main Street appears to have been no exception.

Mills

For some years Cockermouth has been regarded chiefly as a market town and agricultural centre; it has held its charter since 1212. But the town was also for many years a centre of manufacture. The Gote Mills, on the south or left side of the Derwent going upstream, is among the earliest. By the early 1800s it has been estimated that somewhere around forty manufacturing and industrial sites probably existed in and around the town. These appeared to be chiefly textile based, and included cotton, woollen, linen and flax manufacturers. There were also tanners and of course that necessity of every self-sufficient town that was fortunate in having a ready supply of running water, millers of grain.

One of the most famous manufacturing mill families were Quakers named Harris, manufacturers of linen. We are told that they opened their first mill, a former corn mill, on the left bank of the Derwent around 1820. This business grew and in time larger premises were needed, leading to the building of the Derwent Mill in 1834.

They appeared to be an innovative family, open to new ideas. Among other discoveries they pioneered the use of flax as an embroidery thread, establishing that it was capable of taking up and holding brilliant dyes, and was comparable to the much more expensive silk. Harrisons were to gain a worldwide reputation for the quality and variety of these threads.

There can be few people, in Cumbria at least, who have not heard of Millers, the 'shoe people'. Millers moved to Cockermouth from Yarmouth in the early years of the Second World War. They occupied the Derwent Mills site.

Millers finally closed in July 1990. Fred Dibnah demolished the mill chimney in 1992. Since their closure the high rise factories have been converted into flats. The views must be wonderful.

Most of the town of Cockermouth stretches along the opposite (north) bank of the river; its fine broad Main Street (it has no other name) begins at the traffic roundabout in front of Wordsworth House, bridges the River Cocker, and passes under Cocker Bridge on its way to meet the Derwent, before ending just below Castle Gate, with the old market place leading to St Helens Street to the right. This area, including St Helens Street, was one of the traditional market sites, and markets are still held here, Monday being the traditional day.

Monday is also a traditional day for the cattle mart. Mitchells, the local auctioneers, have recently moved to larger premises on the outskirts of the town, but for centuries Cockermouth echoed to the sound of sheep and livestock on market days. Market days must surely have begun long ago, with the livestock held in pens, possibly somewhere around the bottom of Castlegate, after being driven on foot along traditional routes towards the confluence of the rivers.

Although the livestock auction has now moved to the outskirts, Mitchells are still very much part of Cockermouth, and hold furniture and fine art sales regularly in their fine traditional saleroom at the top of Station Street.

Wordsworth House

Wordsworth House was built by Joshua Lucock in around 1746. In 1761 it was bought by John Robinson, the Lowthers' agent, passing to the Lowthers in 1765. John and Anne Wordsworth, William's parents, came to the house on their marriage in 1766, and all their children were born here.

Surely one of the most famous houses in the town, Wordsworth House faces out onto the Main Street, its long back garden and lovely terrace looking out over the Derwent. The poet Wordsworth was born here in 1770.

Wordsworth House is a beautifully proportioned Georgian house, and we are told that several cottages were demolished to make room for it. This seems high handed to modern eyes, but the Victorians were just as destructive. I am certain that most people will already be aware that as well as being born here, this house was the beloved childhood home of William Wordsworth, his sister Dorothy and their three siblings. Their father, John Wordsworth, was agent to Sir James Lowther and the house went with the job.

Interspersed with trips to relatives in Penrith, and a year at infant school there for Dorothy and William, the children seemed to spend a magical childhood in Cockermouth, a childhood cut short when their mother died aged only thirty. William was just eight when his mother, Anne Wordsworth, passed away in Penrith, her home town.

After Anne's death, William and his elder brother John were sent to school, his young sister Dorothy to the care of relatives. When, at thirteen, William lost his father, the Wordsworths in Cockermouth were no more.

The affection and nostalgia that both William and Dorothy were to retain for their childhood home and their family life there is undisputed.

Percy House

Percy House and Wordsworth House have the length of the Main Street between them; Percy House is to the left on the Castle Gate side of the Cocker Bridge. For many years this building comprised two houses and two shops, and possibly had many other 'incarnations' within its long history.

Built by Henry Percy in the 1500s, and believed to have once been the home of the Percy bailiff, the building now houses a shop and gallery. The interior of this building has been beautifully renovated and remodelled while still retaining some amazing surviving original features.

On the upper floor there is a figured, carved plaster ceiling dated (in the plaster) 1598. Also above a superb period fireplace are the arms of an earl, surrounded by a garter.

Old Hall

The Old Hall, by description, must have been almost opposite Percy House. It was to here that Queen Mary was brought by Lord Lowther *en route* from Workington to Carlisle in May 1568. Probably before Percy House was built, if the date in the ceiling is the construction date, and not simply the date of the ceiling.

The story of the queen staying in the house of a 'merchant' named Fletcher, and of her being given the gift of a bolt of red velvet on account of the poor state of her 'attire', is a common one. Given the circumstance of Mary's flight there could be some truth in it.

It is not easy to imagine or describe quite where the Old Hall stood. It is said that at one point the gardens spanned Bitter Beck, which now runs between the back of the houses on the right of market place and the Kirkgate Centre. The footprint of the house itself must, at some point in its complicated history, have covered what is now the Kirkgate car park, and cut into some of the property that is on and around this site today.

The story of the hall is a rather sad one. It appears to have been rebuilt, possibly in a grander style, in the years following the queen's stay. But later it must have gone through periods of alteration and neglect, for we hear of it being sold as a group of properties in 1776.

Over time, it appears to have been built in and parts bricked up, although some signs of lost grandeur were recorded as being still visible. It was 1937 before the council stepped in to rehouse the tenants from the remnants of what by then appears to have been a group of somewhat dilapidated buildings. What was left of Cockermouth Old Hall was finally demolished in the early 1970s.

Cockermouth Castle

With, we are told, short gaps in their ownership, it is the Percies who appear to have held the Castle for longer than any other family. The Percie family would have been resident here when Mary Queen of Scots was brought to Cockermouth by Lowther in 1568. There are many explanations, some of them conflicting, as to why Mary was not held/given hospitality at castle.

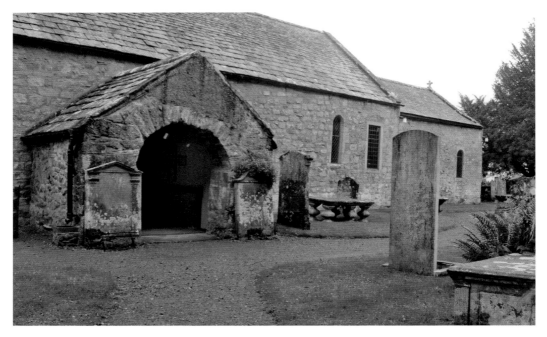

St Michael's church, Isel.

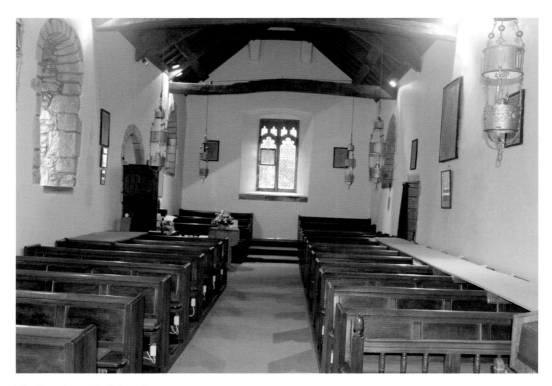

The interior of Isel church.

Above left: The fine Isel font is cut from one piece of stone, and appears as one with the floor of the church.

Above right: An original Norman window in St Michael's.

Isel Hall, photographed with the permission of Miss M. Birkett.

Cockermouth Town Hall. (Mr K. Irvine)

The first stone tower on the castle site was probably from around 1210. It is an excellent defensive place to build, with the end of a steep rock ridge overlooking two rivers. The Derwent gave direct access, not only to the sea but also to minerals and other commodities from the Lake District. There is said to be some evidence of the Derwent being moved closer to the castle mound at this point. Given the nature of this area, I suppose that there is the possibility that it could well have been moved by either nature (flood) or by man.

The castle as we see it now is mainly the result of being partially ruined by Cromwell's forces after the Civil War, in spite of Cockermouth standing for the Parliamentarians. Standing high and proud above the confluence of the rivers, Cockermouth Castle today has the appearance of a spectacular, even artistic ruin, especially when viewed from any of the bridges. However, part of the castle is still occupied, with the inner baileys forming a beautiful home and gardens.

Castle Brewery/Jennings Brewery, gives the impression of being tucked under the castle walls themselves. Jennings have occupied the site and brewed their traditional ale here since 1874.

Markets and Fairs

Cockermouth's Market Charter was granted in 1221, which does something to indicate how important the town and its castle were within the local political scene. The charter, a license to hold markets and fairs, was extremely lucrative and usually granted as a mark of favour. It was the incumbents of the local castle and the ruling family of the area who usually stood to gain most when such charters were granted. In Cockermouth in 1221, according to Bradbury, these were possibly Lucies or Multons, and through a series of intermarriages these families held sway there for something over 100 years.

Cockermouth is still a market town, and well into the last century twice yearly hiring fairs were held in the Main Street and market place. The Monday after Martinmas and Whit Sunday was the traditional day for hiring. There are photographs that show these areas packed solid with people, some hiring and hoping to be hired, others simply taking advantage of a rare day's holiday. There was also an annual cattle fair held in the Main Street on the first Wednesday in May, and a horse fair on Gallowbarrow at Michaelmas.

The definition of 'fair' we are accustomed to today, with rides, sideshows, games and prizes, is relatively new. In the past they were a much more inclusive event, with stalls, local and otherwise, selling a wide variety of goods, pots, ribbons and medicine. There were entertainers, conjurors, fortune tellers and many others. Fairs were special days, perhaps twice a year. Originally fair days were connected to saints' days, and many had connections with the Church.

Markets were much more frequent, usually concentrating on local goods. In the past, fair and market went side by side, especially on public holidays. The town does have an area called 'Fair Field', but like so many other towns it has been built on.

They still hold special fairs in Cockermouth's wonderful Main Street: food fairs and cookery events, full of local produce and some celebrities. But most spectacular of all is the biannual Georgian fair, which began in 2005, when the town is full of people in Georgian costume.

During these festivities some of the town's notable 'events' and citizens are described in 'The Discovery Walk Plays' an integral part of the Georgian fair. They give a snapshot of the town's industry and society of the period, and also demonstrate something of the political background of the time.

I owe thanks to Keith Irving, Cockermouth's Town Crier, for information and help with the following brief description of the locations and characters involved. They give quite an insight into the town's past, and some of its famous and infamous inhabitants. All the locations are accessible around and from the Main Street.

At Wordsworth House young William and his sister Dorothy meet a young Fletcher Christian of *Bounty* fame. He was a contemporary of Wordsworth and they were to spend some time at the same school.

The Sands are the location of the early town mills, an industry reliant on water power. The Reform church sees John Walker, another local alumnus, who is famous as an 'Eminent Vaccinator'. Kings Arms Lane saw the workings of the court leet. Cocktons Yard saw the 'Assessors' appointed by the court leet. There would be pinfold lookers, and market lookers, also assessors for bread beer and other items. One of the 'tests' for good beer apparently involved sitting on a quantity in leather britches.

Isel

Cockermouth Castle sits at the end of a high ridge with the A66 on one side, and the River Derwent on the other. This ridge keeps the major road out of sight and hearing. This is the stretch between Cockermouth and Bassenthwaite Lake. Here the river, snaking and curving, as is its nature, through wonderful tranquil, green and wooded countryside, is little seen even from the quiet side roads.

Isel village spreads from Isel Bridge, past the church towards Isel Hall. This village has a pleasant variety of buildings old and relatively new, but the church and hall are gems. *Lake District Place Names* tells us that Isel is thought to be 'Ise's nook', a nook of land often beside water, ideal and precise when you consider the village's proximity to the Derwent. This splendid book by Diana Whaley goes on to say that as the village is beside the 'meandering' River Derwent, the 'gate' in Iselgate presumably means 'road'.

It was in Isel parish that the murder of Alexander Dykes, mentioned earlier in this book, took place, and the year given is 1499.

Isel Hall

Isel Hall's guidebook adds to this information regarding the source of the name. It states that 'Isel' is Welsh for low, which gives the name a possible Celtic origin. It also mentions Bloomer Beck, which is a tributary of the River Derwent. This beck runs on the site's western side and could give the appearance of Isel Hall being an island, it being built on the northern, more heavily wooded side of the river for protection. Also it is more than possible that the building could have once had a moat, and there is some evidence for this on the north and east side of the tower.

The hall, with various adaptations and alterations, has stood on the same site for almost 1,000 years. As with so many ancient buildings, over the centuries Isel's changes will probably have been a combination of need, practicality, security, safety, and sometimes fashion. As anyone who is fond of architectural history will know, our ancestors sought and enjoyed 'the latest mode' just as eagerly as we do today.

This is border country, safety and protection was paramount, and as with others Isel began with a Pele Tower. Apparently there is no firm evidence as to its date, but various architectural features place it around the fifteenth century. The hall we see today appears to be a wonderful combination of Tudor, Elizabethan and Jacobean.

Such a house with so long a history of occupation does have its stories; one such story is both romantic and sad. It tells of a young General Wolf, then still a major, who met Elizabeth Lawson of Isel Hall in London, and fell in love. We are told that it was probably his mother who came between them, having ideas of a wife of both greater wealth and stature for her son.

The would-be lovers separated and were never to meet again. How mutual the affection was we cannot be certain, but years later Wolf apparently wrote that his 'heart was dead'. What of Elizabeth's feelings? We know little except that she died young and unmarried.

Isel Church

St Michael's and All Angels church stands on a bend of the River Derwent upstream of Isel Hall. I like the possible meaning for the name Isel put forward in the church's excellent history. This was written in 1994 by W. Raymond Hartland and amended in 2010.

I acknowledge both my thanks and debt, as a great deal of my present knowledge of Isel Church is due to this well researched publication.

Basically, through a series of well demonstrated points, this booklet puts forward the idea that name Isel could mean a piece of flat land in a corner formed by a bend within the river. It also says that it may have been given by a man called Isa.

The site of St Michael's, Isel, is 'by repute' an ancient worship site, possibly the site of a preaching cross. There is very likely no way to prove or disprove such assertions, but as in other sites along the Derwent, we have the combination of the river and travelling preaching clerics. It is accepted that succeeding populations use and reuse 'special' places, and it was interesting to see that there is the possibility of an early village above the present roadway. There is also evidence of ancient site near Camerton, and perhaps it is no coincidence that it too sits on a bend in the river.

It is so obvious that Isel's church is loved and looked after. It looks, regardless of subsequent alterations, like a beautiful Norman church. The Normans appeared to often wipe out all before them, and it comes as no surprise to realise that many Cumbrian churches were built and rebuilt in the twelfth century; however, they were fine builders, craftsmen and architects, and they had a gift for substantial arches that somehow still look graceful. Also they did sometimes reuse old stones; old stones give clues and unlike some of their predecessors, the Normans kept records.

St Michael's given date is around 1130. That there have been alterations and additions in something like 900 years is to be expected, but the building still has many of its original Norman features. The interior of St Michael's is full of interest; the fine Norman chancel arch dominates the inner space, as I think it was meant to. Not surprisingly, there has been some repair during its centuries of existence and this is shown by the lighter-coloured stones. Some shaping at the base of this arch's supporting columns suggest that there may once have held a rood screen. Fascinatingly there is a stone to the left of the arch with an incomplete Egyptian ankh cut into it. As most people will know the ankh is a symbol of rebirth, which is an unusual thing to find in a Christian church.

There are a number of interesting stones and stone remnants within and around the building. A stone remnant, identified as the upper end of a recumbent grave slab, has been built into the wall at the vestry end of the church. This has been dated as eighth- or ninth-century, and is possibly the earliest sculpture within the building itself.

One of most interesting stone remnants held within the church was, sadly, stolen in 1986. This was a Triskele stone, and it was displayed on the sill of the tracery window in the south wall. This stone, said to be the upper portion of a composite cross, was discovered built into the 1691 Isel Bridge. The discovery was made when this bridge was rebuilt in 1812.

A second possible Victorian find are two parts of a cross-shaft that probably came to light during church restoration, which was carried out in 1878. These pieces lie inside the building close to the main door.

Another wonderful piece of stone, though obviously not a remnant, is the font. Dated around 1275 and still in use today, it gives the wonderful impression of growing out of the very foundation rock of the church itself. It is suggested that this font may show signs of deliberate defacement inflicted during the Reformation. There is a damaged holy water stoop close by.

The font and stoop are located near the church doorway, which is Norman; here there is some evidence, not only of repair and restoration, but of possible past physical attack. The south porch is fourteenth-century and houses yet another remnant set into its wall, which is part of a medieval grave slab.

In spite of the restoration, renovation, repair and extensions that have been carried out over the years, there are still three original Norman lancets left: two in the north wall and a small lancet by the vestry door. Intriguingly, there is also a 'devil's doorway' in the north wall that was blocked off as recently as the renovation of 1878.

Traditionally, these doorways were opened before baptisms to exorcise the devil. Otherwise such doorways were kept locked and often bolted, due to the superstition that the devil comes from the north. There are or were parts of the northern British Isles who would not have any kind of door or window of a working or dwelling place facing north. This is thought to be due to the 'folk memory' of the Viking and other invasions.

St Michael's and All Angels church suffered in the floods of 2009. I will not describe the painful details. Suffice to say that due to an immense amount of time and work the church reopened in October 2010. Now it once more looks what it is, a beautiful used and cared for place of worship that has served its community for centuries.

Tyths

In common with Camerton, Isel church has an impressive list of incumbents dating back to the twelfth century. There is an interesting tale involving the rights of the incumbent of Isel and salmon. Apparently the resident cleric was allowed to trap salmon on the River Derwent. This story states that the Derwent was so rich in fish, and so many were taken, that there were times they fell off the parson's cart. The local populace were allowed to pick up and keep any fish that were lost this way.

I always think that between Isel Bridge and Ouse Bridge is one of the quietest and loveliest parts of the Derwent; that is, usually quiet in terms of traffic and people. I don't know if it is the effect of the partly wooded banks, or the lay of the land, but on this stretch I believe that you can really become aware of the river picking up speed.

Buckholme

There is a small island on this stretch, downstream of Ouse Bridge, called Buckholme Island. According to Diana Whaley, Buckholme is 'island or water flanked land frequented by male deer or goats; also island wood'. She goes on to say that this small islet in the River Derwent, close to the village of Blindcrake, is more likely to have housed goats. A small island sounds a very practical place to keep 'Billy goats'. Blindcrake is 'the top of a rocky hill'.

Ouse Bridge

Ouse Bridge is a fine stone bridge which arches the River Derwent as it exits Bassenthwaite Lake. The bridge is crossed by the B5291 to join the A591 at a T-junction that will take you via the east of Bassenthwaite to Keswick.

There appear to be a number of possible meanings for 'Ouse', but most seem to agree on pool, or sparkling pool. To say that the bridge and its surroundings are picturesque is somewhat of an understatement, especially when viewed from water level. There is well-marked public access from the Bass Lake side of the bridge.

Did She Fall or Was She Pushed?

Ouse Bridge is the setting for a tale that was, like so many others that are fast disappearing, once well known. I have to thank a friend for reminding me of this particular story, as it is well worth repeating.

This local story has a number of versions, some more elaborate than others. Also, in common with many stories of the fairly recent past, there are said to be reports of the incidence recorded in the local press of the day. As other researchers will recognise, knowing is one thing but finding is another. Versions of this tale have such a persistent similarity, that I am certain there is at least some basis of truth in it. The events are most often believed to have taken place in the late nineteenth century.

A local girl was keeping company with a successful farmer's son who was regarded as a match well above this lass's own sphere in life and expectations. However, the lad appeared keen and the lass persistent. The girl became pregnant, quickly breaking the news to her suitor and insisting that he fulfilled all his promises, which had included marriage 'when the time was right'. When could it be more right?

After some discussion the lad agreed to the banns being called, but he in his turn insisted that she should meet his parents first and was adamant that he would need time to arrange this. Until then their relationship was to remain secret.

Eventually this promised meeting was arranged and it was agreed that he should pick her up in a nearby town – Cockermouth is the location most often stated – and that she would ride pillion with him to Bass and be introduced to his family.

All appears to have gone as planned and the journey progressed smoothly until they began to cross Ouse Bridge, where the lad complained that he could feel the saddle slipping. He urged his 'fiancé' to dismount while he checked the girth. The girl alighted, stepping onto the parapet of the bridge. Stepping onto the parapet is not as odd as it might sound, for it is no mean feat getting off and then remounting a full sized horse when wearing petticoats and without the help of a mounting block. Also, riding pillion, she would not have had the benefit of a stirrup.

It was said to be well after dark when a distraught man hammered on the doors of a hostelry, begging for help. Shaking with shock he explained how his fiancé had slipped from the parapet of Ouse Bridge, and search and call as he could there was no sign of her in the waters below. A further search was instituted without success.

The farmer's son soon appears to have got over his grief, as only two or three weeks after his sad loss, he was in 'merry company' and appeared to be enjoying himself to the full, when he got the shock of his life. His fiancé appeared accusingly before him. Convinced that she was a ghost it is said that he ran screaming from the room, and had to be 'revived'.

Such a public ghost would have been trouble enough, but worse was to come; it quickly became obvious that the girl was flesh and blood, and standing before the assembled company accusing the farmer's son of attempted murder.

She explained how, buoyed up for a while by her petticoats, she had managed to drag herself to the shallows and struggled ashore. Convinced that he had tried to kill her, the girl had not called for help, and she was adamant that he had not attempted to come down to the lakeside to search.

After hearing sounds of him remounting and riding on, she had struggled, half dead with cold, to refuge at a friend's house. Here, she had recovered in secret while deciding what action to take.

Supported by friends the girl went to the authorities and accused her fiancé of attempted murder, stating categorically that she had been pushed. The lad of course denied all, stating that she had slipped.

The girl's story must have been the most convincing, as the lad was duly charged with attempted murder, it is said that he died at Carlisle while awaiting trial.

5

Bassenthwaite Lake

Bass

As most people who are fond of crosswords and quizzes will already know, Bassenthwaite Lake is the only 'lake' in the Lake District, the others either being 'water' or 'mere'. The meaning of the name is not very clear; opinions appear to favour 'broad' water or 'clearing'. Bass is the preferred local name for this lovely lake; it is a National Nature Reserve, and I have to confess that this particular stretch of water is one of my favourites.

In form, Bass is long, narrow and relatively shallow, being 3–4 metres deep at its centre, although there is a deeper pool around Scarness point on the northern side. The present Bass Lake is only a remnant of what it was, if history and geology are to be believed. At some period in the distant past, Bass and nearby Derwentwater were one large stretch of water and must have incorporated the substantial area of marshland that still exists between the two. The sides of Bass are well wooded, and do a great deal to mask the amount of traffic that passes either side of the lake rendering it barely visible, for most of its length, either from lake edge or the water itself.

Main roads pass either side of the lake, to meet and then again take their separate ways on the outskirts of Keswick, the A591 toward Kendal, the A66 to Penrith and beyond. The A66 takes the lake's western shore closely following the line once taken by the rail track, and at one point incorporating part or the old road to create one of the prettiest pieces of dual carriageway that I know, weaving through woodland along the lake shore between the Pheasant Inn and Beck Wythop.

The A591 follows the Skiddaw side, and this road takes its line well back and slightly above the shoreline, with Bass is still in view for most of its length. When approaching the Keswick end of the lake, you can easily look down onto the bog which still joins Bass and Derwentwater, getting a clear view of the budding River Derwent at Derwent Foot as it enters the lake.

Skiddaw

The mighty bulk of Skiddaw dominates Bass Lake. According to *A Dictionary of Lake District Place Names*, Skiddaw is 'possibly the mountain with the jutting crag', and could

be Scandinavian. This famous hill has been the focus of many local events. The people of Keswick seemed to have an inclination for celebratory bonfires; celebrating with some gusto, if the local accounts are to be believed, among others the anniversary of the defeat of the Spanish Armada. There was also a well recorded and long spoken of famous celebration on the occasion of Queen Victoria's Diamond Jubilee.

A side story to all this speaks of some possible rivalry between the Burgers of Keswick and Carlisle, as to which town would have the largest beacon/bonfire. I am assured that on a clear night these fires would have been visible from one location to the other. I have never been in a position to check, but it might prove interesting.

There are numerous stories concerning these huge bonfires, and it must have taken days for men and mules to toil up the mountain carrying tar barrels, peat, straw and other combustibles. I believe that these fires were built somewhere near the modern trig point, and were of a 'considerable' height. A barrel of rum was, so rumour has it, also included in the necessities of such occasions, and a kettle of water. There is no water on Skiddaw and rum and hot water were usually consumed in any appropriate toast.

Any such occasion appeared to have half the population of Keswick toiling up the slopes of Skiddaw, including of course dignitaries plus the famous and distinguished, who were normally well to the fore in the organization and the raising of funds.

There are of course many tales, amusing and otherwise of 'incidents' and 'happenings'. One or two such mishaps, which I obviously cannot vouch for but are often repeated, concern Mrs Rawnsley and Wordsworth.

Apparently Mrs Rawnsley was given the honour of lighting one of these huge bonfires, when the time came she was given a flaming torch on the end of a long pole, so that she need not approach the fire too closely. Thank goodness someone had this foresight, for an accelerant had been added to what was already a somewhat combustible mixture, and it is said that the unfortunate lady was blown head over heels, crinoline and all.

In the ensuing furore as she was picked up and dusted off, none the worse apparently, Wordsworth kicked over the kettle of water (although he was later to deny it) rendering it necessary for the loyal toast to be drunk in neat rum. Local lore tells us that it took two days for everyone to vacate the mountain.

Ullock Pike

To the left of Skiddaw is Ullock Pike. There is also a village named Ullock, but it lies some 3 miles plus from the Pike, thus making it unlikely to have any connection, except perhaps by name. Word lists and some dictionaries associate the name with wolves, and the hills above Braithwait on the opposite side of Bass, are quoted in local lore and tradition as one of the places where the last wolves in Britain roamed and were hunted.

However, the traditional local meaning of Ullock has always been quoted as meeting or gathering place. Perhaps long ago there was a more local, now forgotten name, and somehow over time the usage of place has been remembered, even though the name has changed. The name Ullock is often said to be of Scandinavian extraction, but there have been settlers at Bass and the surrounding areas since long before the time of the Vikings.

Latrigg

To the right of Skiddaw is a much lower tree-covered peak; this is Skiddaw Dodd, an excellent short-ish walk. To the right again there is Latrigg; in common with Ullock Pike, it appears like a shoulder sweeping away from Skiddaw's main peak.

As well as being an excellent walk Latrigg is also a favourite take-off point for hang-gliders. It is wonderful to watch their bright canopies soaring high above the lake, totally ignored by the ospreys. There is a car park high on Latrigg, approachable from the outskirts of Keswick; this can prove a good shortcut to the top and the view is worth it.

Barf

On the A66 side of Bass, a wooded craggy ridge is set well back from the road. A bare-looking, extremely steep mountain, which at first glance appears to consist mostly of shale, stands out from this ridge. Called Barf, it is unmistakable, partly due to the large, white-painted rock high on its side. This rock is the 'Bishop' and it is part of the folklore of Bass.

The story of the 'Barf and the Bishop' is said to be so ancient that it is untraceable. Times were bad and a certain monk was unable to afford his due rents. So his landlord told him that if he could ride to the summit of Barf on his donkey, all debts would be cancelled. But he had to ascend the side facing the lake, which is obviously by far the steeper. The unfortunate brother fell to his death from a point close to the Bishop rock, which ever since has been painted white in memory.

There is also a similar much rarer version of this story, involving a gambling bishop and the payment of debts. Possibly the more unlikely of the two tales?

In defence of either story, it has to be said that the abbeys both rented and owned lands in and around Lakeland. Furness Abbey, to name one, had connections with Borrowdale, so perhaps there is a foundation of fact buried somewhere in the story of 'Barf and the Bishop'?

The Swan Hotel sits just below the Barf, and it said that they keep a bucket of whitewash for anyone who will offer to climb up and paint the 'Bishop' – the reward is a free pint. Be warned, as from this side, it can be a steep and difficult little hill.

Whinlatter Pass lies just beyond the ridge of which Barf is part. To ascend the pass itself, take the first right beyond Braithwait, and go towards Keswick. Driving up from the Bass Lake side, there is a car park with a spectacular view to your right. The sides are heavily wooded so obviously the view is clearer in autumn/winter, but from here you can get a good sense of the Derwent feeding through the bog between Bass and Derwentwater. This view is even better if you continue up to Whinlatter Forest Park and take a marked trail to the top of the ridge.

Either viewed from above or the side, it is obvious that Bass and Derwentwater, the Derwent's named lake, really were once one stretch of water. This is now well accepted and regarded as fact; it is also accepted that they were one stretch of water 'within the time of men'. There have been times, dare I say quite recently, when they have looked pretty close to being a single lake once again.

There is something very special about an area that has been lived around, used, and enjoyed for uncounted generations. It is part of the nature of such places that they appear to collect and to keep alive folk tales and traditions. They say that folk tales are the memory of man, and history is a record of his exploits. This opinion does not always hold, but there is a lot of truth in it.

Peel Wyke

There are a number of what have been described as possible Iron Age defensive forts close to and above both Bass and Derwentwater; they occupy 'perfect defensive lookout positions'. Some have been excavated and investigated, some not. None, to my knowledge, have been touched for some years.

One of the most famous and better known is Peel Wyke (peel is defensive, wyke is bay), on the south side of Bass. This has been investigated in the past and reported to appear 'defensive'. The most often-heard tale of Peel Wyke is that this is one of the last places in Cumbria where fairies are said to have been observed.

The most recent tales were still well known and talked of in the nineteenth century, and one describes a tiny building (a little creature's dwelling) being discovered on the fort mound by two boys. The other talks of a farmer and his dog having a confrontation with two tiny men dressed in green in a field close to Peel Wyke. Apparently the dog, a somewhat bad-tempered creature, got the worst of the confrontation.

Stories of both fairies and wolves within one area say something of the communities that must have lived here, and the longevity of communal memories, if nothing else does.

The old railway station was close to Peel Wyke, and some of its remnants can still be seen in a patch of woodland that lies between the old and new A66, near the Pheasant Inn. In the years after the war there were camping coaches next to this station, and possibly earlier still there was a local rowboat taxi service between here and Scarness on the Skiddaw side of the lake. This was of course before the days when licence and safety was an issue and one more example of how the water, river and lake were used for the day-to-day convenience of the local people.

There are no longer rowing boats to hire on Bass Lake, as I recall anglers seemed to be regular customers. There are still anglers frequenting Bass, but I have been unable to find out exactly when the hired boats disappeared. I remember them in the 1960s, and several people have told me that they were still for hire in the 1980s or perhaps later. These boats were stationed by concrete landing stages close to Peel Wyke. On the OS map this area is also marked as Castle How and fort.

My husband has fond memories of helping a friend who helped out the rowing boats' owner, in school holidays. Payment seemed to have been unlimited access to the boats.

Memory is notoriously bad when it comes to nostalgia; I do, however, clearly recall some long wooden rowing boats, hauled out of the water for winter and turned keel-up on their stands. Freshly varnished, they spent the off season by the grassy shore at the Keswick end of the dual carriage way. I have been told that these were privately owned craft. The only powered craft allowed on Bass is a safety boat.

Fishing

Some more recent tales concern giant pike. In common with a number of other stretches of water Bass is said to house a true giant who has managed to escape capture on many occasions. When I was a child I well remember large pike being caught here, and now I am told that, sadly, they are not so plentiful. But it is, I am glad to say, still a common sight to see the anglers' tents, and the rods and bells on stands at the water's edge.

I have been told that of the live bait needed to catch pike any unused surplice is tipped into the lake and that over time this has added to the variety of fish found in Bass, Derwentwater and ultimately, the Derwent.

Bassenthwaite Sailing Club

To most locals, and indeed many visitors, it would be difficult to imagine Bassenthwaite without yachts. We have become so accustomed to seeing them gracefully skimming the water that they have almost become part of the lake scenery.

The sailing club sits at the sea end of Bass, its land embracing the top of the lake on the A66 side of Ouse Bridge. The view of Bass from this vantage point is unexpected and beautiful. Unexpected because the 'kink' in the Ouse Bridge end of the lake effectively hides its length from this angle, and you find yourself looking out at a wide, tree-rimmed, peaceful bay. You can just about see Armathwaite Hall, peeping above the trees on the Skiddaw side. Armathwaite has its own spectacular lake frontage, this and the generosity of the then owner, was to prove instrumental in the birth of the club.

Bassenthwaite Sailing Club was formally founded in 1952, the original inspiration had come from two solicitor brothers, Ieuan and Elwyn Banner Mendas, who themselves had been enthused while on holiday in Wales with their families in 1951, just a year before. Having tasted 'messing about in boats' they had returned to the lakes determined to search for a site suitable for the founding of a family sailing club.

Bass was suggested but at first there were questions regarding local warnings of squalls, but a flourishing yacht club had existed on Lake Windermere since the nineteenth century. This fact, and a visit to see the Windermere yachts race, proved inspirational. This led to further research and it was eventually determined that Bassenthwaite Lake would make 'admirable sailing water'. Bass was also a suitable candidate because of its proximity to the main west Cumbrian towns.

The next problem was finding a stretch of land suitable to enable the boats to be beached. It was to be Mr Alec Wivell, the then owner of Armathwaite Hall Hotel, who came to the budding club's rescue. Armathwaite faces due south looking down the length of the lake towards Keswick, and its superb wooded grounds run right down to the water's edge. Not only did he allow the club use of his hotel beach, but also permission to use the changing hut that had been erected for the convenience of hotel guests.

Bassenthwaite Valley drains a wide area of land, the lake being reputed to have the highest rise and fall of any stretch of water in the area (I presume not counting the lake reservoirs). The rise and fall of Bass is said to be some 10 feet. This restricts usable lake shore and obviously made the search for a permanent home for the club even more difficult.

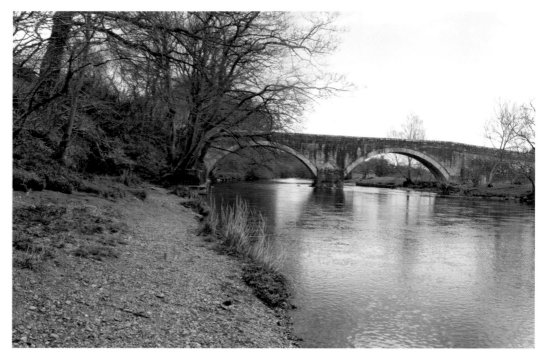

Ouse Bridge, the River Derwent's exit from Bassenthwaite Lake.

Wood anenomes near Ouse Bridge.

The bay just off Bassenthwaite Sailing Club.

The rescue boat, with Skiddaw and Latrigg in the background.

The clubhouse.

The River Derwent entering Bassenthwaite Lake.

Eventually the present site was found and purchased, but not without a planning inquiry and objections from residents. All was successfully negotiated and the planning inquiry won by Ieuan Banner Mendas on appeal. The club has been in its resulting permanent home since 1956.

Today the club occupies an excellent 6½ acre site, including enviable facilities including disabled access, and a healthy membership that is obviously thriving. Families are encouraged and catered for and one of the first things you become aware of as you enter the clubhouse, is the children's corner.

At one and the same time there appears to be overall sense of community and a welcome for new members and visitors. In fact one of the first things that you see on approaching the club site is a sign of welcome.

St Bega

This simple and beautiful church of St Bega lies in open grassland some yards back from the lake shore on the Skiddaw side of Bass at the aptly named Church Bay. This church is an enigma, sitting here, some 30 miles from what was possibly the mother church at St Bees on the West Cumbrian coast. For Collinwood himself declared that there are only two churches named for Bega, and this, small and serene by the shores of Bass, is one of them. Giving pause to think, why here?

A free leaflet available in the church itself declares the building to be 'situated on an ancient roadway leading from Little Crosthwaite to Bowness'. Bowness wood protrudes into the lake just to the right of St Bega's church, separating Bowness Bay from Church Bay. Crosthwaite church is said to have been the site of a preaching cross, it gives pause to wonder about the siting of this church of St Bega's.

In Cumbria old roadways and pathways are traditionally called 'throughways' or sometimes 'foot-trods', familiar in other parts of the country as 'greenways' or 'hollow ways' These pathways are ancient indeed.

There are Iron Age sites around both Derwentwater and Bass; perhaps this gives pause to wonder just how old the actual church site is? The informative leaflet also tells us that stones within the church's outer walls could be Roman, and also that the chancel arch is 'indicative of Norse or pre-Norman'. It also tells us that the chancel and nave of the original part of the building probably dates from around AD 950.

Inside the building, it is plain to the point of austere, and therein lies most of its beauty. On one of the windowsills there was a framed copy of 'The Hymn to Bega' (I presume it is still there) which mentions Bega's 'ring'. Some people seem to think that this hymn to Bega was a Victorian invention, which it probably wasn't, although indeed some commentators think that Bega herself was an invention, which I suppose is possible.

There are many stories and opinions on this saint, including the doubt as to her existence. Her story obviously has great variations; a simplified outline of the most accepted brief version is as follows.

Bega was an Irish princess, and when threatened with an unwanted marriage, she fled alone, across the Irish Sea to be washed up at St Bees on Cumbria's west coast. Bega had in her possession a silver amulet (the Mystic Ring) that was said to have the power of healing. At St Bees she founded an order of nuns that became known for their charity and healing.

This was around AD 6500–6800 (a wide margin). There is divided opinion as to whether the original foundation is pre- or post-Viking.

By AD 1100–1200, Bega had become a canonised, Christianised saint named Bridget. It is recorded that some of her relics including an amulet/bracelet were lodged in the abbey at St Bees.

There are a number of churches in Cumbria named after Bridget, and most are at least part Viking and Norman in style. All have unprovable suggestions of original foundation, at least as old as the story of Bega. Many are, by repute, regarded as ancient worship sites. Given Cumbria's violent past history of invasion and destruction, how could such claims ever be proved or disproved?

One of the most persistent suggested stories regarding Bega is that she fled to Cumbria because there was already a Bridget foundation here. Bridget, or Bride, was regarded as a deity in Ireland long before Bega's time. Cumbria has often been regarded as once having an inclination towards female deities.

Traditionally in Cumbria both the names Bega and Bridget are often replaced with Bride; this would have been familiar to our grandmothers and generations before them. I have read that Bridget/Bride was invoked as a blessing at country weddings in Ireland as late as the First World War. Look out from almost any high point on the Cumbrian coast on a clear day, and we are physically much closer to Ireland than most people realise.

All this has the possibility of making the tiny gem of a church and the area of Bass itself even more special. Perhaps there is the possibility of this church occupying a special site that is even older than the stories of Bega. Local history tells us that this church of Bega is set within the remnants of a stone circle. The ground on which it is set has the suggestion of a mound.

Oak trees flourish here, reminding us of how our wonderful Lakeland could have looked long ago. The bog at the Keswick end of the lake where the River Derwent feeds in has petrified oak just a few feet down, and the Derwent itself is oak river. All serve to remind us of the sacred groves of myth.

St Bega's is an unsurprising favourite with today's brides, and what a wonderful place to take your wedding vows. Lake, trees, the light and atmosphere somehow combine to make it a glorious setting. The church is approached from a side road well marked from the A591; it is a lovely walk across the meadows and well worth doing.

Mirehouse

The church is also approachable from Mirehouse. Sitting close to St Bega's, this beautiful house shares the magical atmosphere of the area. The Building and grounds being much commented on, past and present, for their tranquillity and setting.

There is evidence of the house's unbroken ownership since 1688. For this and indeed, for most of my information concerning Mirehouse, I owe a debt of gratitude to the present generation of owners, who have also allowed me use of their current guide book and photographs.

Records exist of Mirehouse being occupied in the sixteenth century. It was the 8th Earl of Derby who had this house built in 1666, selling it in 1688 to his agent, Roger Gregg; the only time that this house has been sold. Originally a much smaller building, the house has been altered and extended over the years.

John Spedding of Armathwaite was bequeathed Mirehouse in 1882 by Thomas Story, portraits of both recipient and benefactor can still be seen in the house in today. It was James, the younger son of this John Spedding, who produced a fourteen-volume edition of the life, letters and works of Francis Bacon. Interestingly, for lovers of Shakespeare, this James Spedding would 'have nothing' of the theory, proposing that Bacon and Shakespeare could have been the same person. A copy of his work still resides in Mirehouse. This James Spedding had many friends and acquaintances among the literary figures of his day, including Fitzgerald and Thackeray.

Alfred Tennyson and John Spedding were close friends. Tennyson was to visit Mirehouse many times, including spending part of his honeymoon here. Perhaps the poet's most famous connection with this literary house was the possibility that this is where he worked on *Morte d' Arthur*, and was said to have been inspired by the atmosphere and setting. Can anyone who has heard of Tennyson's connection with Mirehouse, read *Mort d' Arthur*, and who has seen St Bega's church, not have looked and wondered? There is a simple open-air theatre at Mirehouse constructed in 1974 for the reading of *Morte d' Arthur* to the Tennyson Society in the place where the poet was thought to have composed most of the poem.

It is interesting to speculate whether or not Tennyson had heard of the legend of Bass Lake's 'Lady of the Lake'. On certain moonlight nights she is said to rise from the water close to Peel Wyke, shimmering like a column of silver. Any story of the reason for her appearance has, sadly, long gone. Whether or not Tennyson or his hosts had ever seen or even heard of this apparition is a question that will probably never be answered.

The lovely gardens and walks of Mirehouse are open to the public, and there is a superb wildflower meadow. Another particular point of interest is Catstocks Wood, lying close to the water's edge. Here a belt of scrub has been deliberately left by the lake shore as a haven for wildlife, and the area has been designated a 'Site of Special Scientific Interest'.

As already stated, Bass Lake is in fact a National Nature Reserve and the whole area is a haven for buzzards, roe deer, badgers, red squirrels, foxes, a host of smaller wildlife and a multiplicity of birds, including of course the spectacular osprey.

Osprey

These wonderful migratory birds are almost as famous as those of Lock Garten near Aviemore in Spey Valley. There are those who would argue more famous. At certain times of year it is common to see people in the lay-bys along the lake shore with binoculars and cameras. There is an excellent viewing facility, open from April to September and complete with information and volunteers, above the Saw Mill tea rooms' car park in Dodd Wood on the Skiddaw side of Bass. The entrance is to be found just opposite Mirehouse, who share the car park.

A partnership project was formed between the Forestry Commission, the Lake District National Park and the Royal Society for the Protection of Birds. A nest platform was constructed in Wythop Woods on the A66 side of Bass Lake, and it was to this that the ospreys returned in 2001 after an absence of over 150 years. This return was the culmination of years of hard work and dedication.

These wonderful birds have returned and raised at least one chick every year since then. They have now 'swapped sides' and now occupy a nest site in Dodd Wood. For those visitors who do not wish to follow the trail at Dodd Wood (it is well marked but does involve an uphill walk) there is also a 'live web cam' of the nest site and a lot of information at Whinlatter Forest Park Visitor Centre. Whinlatter is well marked from Braithwait on the A66.

I am in the fortunate position of having seen birds on many occasions, but to date have never seen one actually fishing. So much is a matter of luck. Thinking of luck, one particular experience sticks in my mind: early one misty morning an osprey shot low over the road a few yards (or so it seemed) in front of the car and flopped down in a field. Whether or not this is typical behaviour I have no idea, but it was quite a sight.

The River Derwent, having picked up the flow from the River Greta, enters Bassenthwaite Lake at Derwent Foot near Little Crossthwait, which lies just above Mirehouse. This is the head of the lake, and although there are some tracks marked, the top end of Bass is basically a bog and needs to be treated with care. On the OS map it is marked as rough mire, with one point actually marked bog hole.

Like all such places, the 'Bog', as it is known locally, is a wildlife haven, and at the right time of year it is full of golden yellow marsh Iris. Newlands Beck also enters Bass through the Bog; its point of entry is separated from Derwent Foot by Redness Point.

Beyond this Bog, the A66 and A591, which between them encircle Bass, meet at a roundabout on the outskirts of Keswick. The town is often nicknamed 'Queen of the Lakes'.

The author's house. (Courtesy of Mrs Spedding)

6

Derwentwater to Borrowdale

Keswick

The River Greta runs through Keswick to join the River Derwent, just downstream of Derwentwater. As one river they pass under two roads: first the B5289 at Derwent Bridge, and then the A66, before twisting across the marshland heading for Bass.

The name Keswick does not appear to have a firm translation, the closest agreed meaning is something in the area of butter or cheese market, while Collingwood in his *Lake District History* uses the term 'cheese dairy'. It is also possible that the name could refer simply to an area or gathering place.

It seems that relatively little is known about Keswick's early years and development, and in many ways it would appear that Crossthwait, situated on the outskirts of the town, could once have been regarded as having more importance; and what was to become Keswick was simply a building or buildings, beside a track between Crossthwait and Derwentwater.

If you ignore the present town buildings and simply follow the line of the road from Crossthwait church, across the area where the Moot Hall now stands and bear right down Lake Road, dropping towards the lake edge, you realise that the whole market area stands on a slight rise overlooking, or perhaps even incorporating, what must once have been a path down to Derwentwater. There is a possibility that 'moot' could mean a meeting place or assembly place associated with a hill. Anyone who knows Keswick at all will of course already be aware that this central part around Main Street, Moot Hall, the upper part of Station Street, is slightly elevated.

Why not simply bear right across the fields from Crossthwait church to reach the lake's edge? It is possible that there is an old path or through way in this location, but you would be crossing land that is for most of the year marsh. This area still holds a great deal of water and one look tells you that it is natural flood plain.

It is broadly believed that Keswick first began as a group of hamlets, probably around what is now the Main Street and Moot Hall; also, some fairly early descriptions mention two rows of cottages in what could possibly be termed as a street. The descriptions are not clear, but perhaps Collinwood was correct in his translation of 'cheese dairy' and a hamlet eventually grew around such a place. There still is, so I am led to believe, at least one spring

under the present Main Street, so there would have been fresh water in this central area. As in many other towns, the eventual need, for public health's sake, to both expand the fresh water supply and have secure reliable drainage and sewer systems, has altered many old water courses.

Keswick seems to have been a place of trade from the earliest of times, and this gives pause to wonder if there was a cross or marker on or around this central site before the Moot Hall existed. Indeed Keswick does appear to have had what could be termed a market, or something very like it, throughout its existence.

Eels, salmon, mutton, linen and woollen goods, as well as eggs, butter and cheese, were among the goods for sale when Hutchinson visited in the 1700s. He was to dismiss Keswick as a 'mean village', but on the whole this solicitor from Barnard Castle was capable of being fulsome in either praise or blame when describing most of his travels.

In their *Looking at Cumbria*, Herbert and Mary Jackson mention the Keswick hiring fairs being held at Whitsun and Martinmas, both traditional occasions until the twentieth century. In the same book they also mention the possible date for the origin of all such fairs, the passing of the Statute of Labourers in 1349. Once again, it gave me pause to wonder just how old some of our hiring customs and traditions could be.

They also describe a time when a particular Keswick market desecrated the Sabbath. It appears that a local congregation got into the habit of bringing goods to church and an unofficial regular event developed in the churchyard at the conclusion of the service. (They don't say which church.) Apparently the ensuing trade began to affect the business in Cockermouth market, to such an extent that in 1306 the king was petitioned and a proclamation issued against such practices.

Most of the older parts of the town of Keswick sit beside, yet slightly above, Derwentwater, in fact Derwentwater is more often and totally inaccurately called 'Keswick Lake'. Although it might not always seem so, the town has a reputation for having better weather than the countryside that surrounds it. As any local will tell you, this is on the whole truth. When approaching Keswick along the A66 near Braithwait it is not uncommon to see a definite 'cloud window' above the town, possibly an effect of the surrounding hills.

Keswick, not unsurprisingly, is encircled by hills. As you approach the town from the west the dominant ridge beyond Skiddaw is Helvelyn and the Dodds. These hills overlook Thirlmere and at over 3,000 feet. Helvelyn is the second highest peak in the Lake District.

Three major passes, Newlands, Wynlatter, and Honister, come down to the flood plain around Bass and Derwentwater. Although while not precisely at the foot of any of these passes, the original hamlet that was to become Keswick apparently began on raised ground, within a flood plain between two lakes.

That there was early and continued settlement within the area is, in common with so much if not all the Derwent Valley, undisputed. There is literally a ring of remnants of early fortification apparently encircling Bass and Derwentwater, appearing to surround them both as one unit, which of course they once were. In fact these two stretches of water have probably gone through many fluctuations and combinations of alignment and juxtaposition over the millennia.

The possibility, indeed reality, of an early sophisticated and organised society is becoming more accepted. Add the richness and convenience of the river and its hinterland and lakes

to the mineral wealth of the mountains and here, in this area, you have all the ingredients. I need hardly add that Castle Rigg is just above Derwentwater, and the Embelton sword was found just beyond Bass Lake. The timespan that separates them and the societies who created them is difficult to envisage. Also, Romans, Vikings, and of course the Normans have, in their turn, all left their mark on the surrounding areas.

As well as its longstanding thriving market trade, it appears most likely that Keswick, like so many towns, has gone through a number of phases of natural expansion and the drive for each phase has been at least part based on industry, whether manufacturing, mining or tourism.

Mining

There is divided opinion as to whether or not the Romans mined copper in the Keswick area. They traded and used the metal, but there appears to be little evidence, if any, of any Roman mining operation. There has been so much mining within the area since, I presume it is possible for any obvious evidence to have been destroyed by later workings. Also any signs of early extraction of ore might not necessarily be Roman. The Embleton sword has a bronze scabbard and has been given a date of 50 BC.

Information regarding both mining and smelting is less elusive from the sixteenth century onwards, when the arrival of skilled German miners were to prove the driving force for the expansion of Keswick from a village to a small prosperous town. Elizabeth I was more than approving of such an expansion, and in 1568 the 'Mines Royal' was born, giving the Crown options on a healthy proportion of all silver, quicksilver, gold and copper, plus a proportion of any precious stones found in the Lake District mines.

A mine named Goldscope was to become one of the most famous and prosperous sources of copper ore. This mine was not finally abandoned until 1923, and its spoil heaps can still be seen.

Another source of mining wealth that still has an effect on the town's economy is graphite. Graphite is possibly the more recognisable name for the substance also known as black cawke, plumbago or black lead. Our grandparents would have been more than familiar with black lead. I do 'just' remember leaded grates.

There are a number of well-known folk tales concerning the discovery and original uses of graphite. The most often repeated and accepted story tells of a shepherd discovering graphite under the roots of a tree. He was soon to realise that this rather odd substance was useful for marking sheep, possibly because he first got himself well and truly stained with it.

In time other uses were discovered for this useful material; these included use in medicine and cures of various kinds, but most profitable of all was the use of graphite within the arms industries. Here it was to prove invaluable in casting. In fact, over time the mining of graphite was to prove one of most valuable of the area's industries.

Pencils

How can you think of Keswick, mining and lead without thinking of pencils? This, one of the best-known graphite based industries, still flourished in Keswick until recently. The Pencil Museum now occupies the site of the town's last pencil mill.

There are claims but little information on regarding the 'first pencil'. Where or when did the idea of encasing graphite within wood first arise? Lead can be both soft and brittle. Of course now it is well known that the graphite is combined with certain clays to strengthen it and make it more malleable thus assisting the encasing process, but where this original idea came from still seems to be a matter of debate.

Although much earlier dates are proposed, including the Elizabethan era, there is so little information that some of these earlier claims could well be true. It is around 1800 when we first hear of pencil makers, and 1830 that there was a pencil mill in Keswick.

Now pencils are available in an *astonishing* range of colours, and although, sadly, they no longer use local graphite, the pencil industry is still alive and well in Cumbria. Quite a legacy from a sixteenth-century shepherd who thought that the strange soft black material he found was useful for marking sheep.

Tourism

In around 1902 Collingwood described Keswick as 'an ancient market town', adding mining, pencil making and wool as the town's industries. He also states that the town is 'now a great tourist resort'. I always presume that Collingwood meant that the town and the attractions of the lakes were more open and affordable to a wider range of visitor by the early 1900s. Or maybe he was differentiating between 'visitor' with weeks or even months at leisure, and the 'tourist' with less time to spare?

As well as the poets, writers and artists regarded as synonymous with the area, Keswick and other parts of the Lake District had been attracting a wide variety of people as a holiday destination since the mid-1800s. Also, the Alps were attracting British climbers, and the lakes were attracting the returning 'Alpinists'. Many international climbers still train in the lakes, while still regarding the Lakeland peaks and crags as worthy destinations within their own right.

Other groups became attracted to the town as a centre. What was to be the first Keswick Convention was held in 1875. Tradition tells us it lasted for three very wet days. Over the years the convention has gained a somewhat unfair reputation for attracting bad weather. The Keswick Convention now lasts for two weeks and for some years has attracted people worldwide.

Keswick has long been firmly established as one of the premier tourist destinations of the Lake District, offering attractions that early travellers could hardly have envisaged: including an indoor swimming pool, mountain bikes, hang-gliding, wild swimming, yachting, canoeing, and pony-trekking. Pony-trekking of course, or something rather like it, complete with wonderful picnics and an army of guides, would have been recognisable to some of the early visitors. However, I am inclined to wonder what some of the early climbers would have made of a climbing wall?

Climbing

I am not sure if you would or could call climbing an industry, or tourism. Basically such a debate would be no more than a play on words. For it is true that most people make a direct association between Keswick, Borrowdale and climbing.

The town is now, as are others within the lakes, replete with shops selling climbing and walking equipment. One of the most famous, indeed world famous, and oldest established shops is George Fisher on Lake Road. As demonstrated by letters sometimes displayed in the window, international correspondence has reached here addressed simply as Fisher's, Keswick.

This shop occupies a tall slate building wrapped around a corner site. This was originally built in 1866, as a combination of shop and studio for the father of the Abraham brothers, who were photographers. The brothers George and Ashley were two of the earliest Lake District and mountain photographers.

If you have any knowledge of crags and of climbing, looking back at the Abrahams' work, and at some of the locations where they must have hauled and held early cameras, takes the breath away. They were both enthusiastic climbers and fine photographers, and some of their work is still unsurpassed today.

According to Alan Hankinson in his book *Camera on the Crags*, the Abrahams' earliest photograph to survive in negative form was probably taken by Ashley in 1890. This shows George and another of his brothers, Sidney, on a cliff adjoining Sharp Edge on Blencathra.

Modern Keswick

In spite of the obvious alterations and rebuilds, central Keswick still retains some of the quaintness of an old town perched at the side of a lake. The town of Keswick as we see it today appears to be mainly Victorian or Edwardian in build. There are of course modern incursions and alterations. Also, in some of the back streets tucked between the long rows of Edwardian terrace that blossomed as the town became a popular and flourishing visitor attraction, you will find enclaves of much older, smaller, slate-built cottages, and some quite lovely Georgian buildings. Many of the houses of all eras are built or faced in slate; such buildings would now be virtually unaffordable. Modern Keswick also still retains that necessity of the early holidaymaker, a large park. Upper and Lower Fitz Park is now split by Station Road.

In common with Cockermouth, the Main Street in the central part of Keswick is just that – it bears no other name. The Main Street widens around the Moot Hall to become the market place. The Moot Hall itself has a famous clock that has only one hand. This clock has a very early date which is believed to be spurious. The upper floor of the Moot Hall was, in the past, used for council meetings. The ground floor being open at the sides, this was where the sellers of butter, eggs and cheese sat on market days. It reminds me that the sellers of these commodities were by tradition always given the choice place in markets, under the market cross.

Now the tourist information centre is to be found occupying the ground floor, and the upper floor, approached by an outside staircase, is often used for exhibitions. Regular Saturday markets are still held around the Moot Hall occupying the market place and Main Street. There are also regular food fairs and a Christmas market. To the right and ahead of the Moot Hall is Lake Road, eventually leading down to Crow Park, at the Bass end of Derwentwater Lake.

One of the finest and most popular views of Derwentwater is to be had from Crow Park, a popular venue for picnics and events since the sixteenth century. This broad, grassy hill is part of the bank that stretches upwards towards the town. Obviously buildings now hide the contours, but up to the early 1800s, the spot where most of these buildings now stand was still grass, and the roads rough paths. There were, in the past, large numbers of tall trees in this park. I have always presumed, as have many others, tall trees link to crows, and crows to Crow Park? I have, to date, not seen any other explanation.

Derwentwater Lake

To look up Derwentwater from Crow Park, and see it in that strange grey and silver-blue half-light that can look like a colour negative, you no longer wonder why this 'Land of Lakes' was once thought magical, and the rivers and lakes haunted by water sprites and nymphs. It is easy to see why the Norse believed that these mountaintops were the homes of their gods.

At 3 miles long and 1½ miles wide, Derwentwater is the Lake District's third largest lake. It is relatively shallow, averaging 15 feet for the most part, but it does have a deep point of 75 feet, which makes it on average deeper than Bass. The River Derwent leaves its named lake at Derwent Bank, between Nichol End and Crow Park, on the western side of the lake. Derwentwater is encircled, almost enclosed by mountains. On the western side, Grisedale Pike stands high beyond Swineside. Progressing toward the head of the lake are Causy Pike, Hindsgarth and Robinson; these two last mentioned long, ridged fells overlook Newlands Pass.

Next is Catbells, one of the most popular tops with early walkers. To walk from Keswick and do Catbells was once regarded as a good first top. It's a steep little hill, and not always as simple as it looks, and the name possibly means 'steep'. Towards the head of Derwentwater is Maiden Moor, and in the distance Great Gable, Scawfell Pike and Ling Mell.

Although dwarfed by the surrounding hills, it is Castle Crag that dominates the head of Derwentwater. It does not take much imagination to transform its distinct shape into a castle, especially in the mist. This crag marks 'the Jaws of Borowdale', and there are, or were, signs of defensive building, an Iron Age hill fort on the top of this stony outcrop. This reminds us that the translation of Borrowdale is 'valley of the Borgara', the river by the fortification. Castle Crag actually occupies a good defensive position.

Beyond Castle Crag, Glaramara and Eagle Crag can be seen at the head of Borrowdale. These hills overlook Watendlath (the smugglers' valley). This is not translation, merely old

folklore. The steep and narrow road to Watendlath peels of the Borrowdale road (B5289) at the lakeside. This, the eastern shore of Derwentwater, is overlooked by the steep, heavily wooded Walla Crag of Lady Derwentwater fame, then the popular climbing crags of Falcon and Shepherds.

Some Lake District names appear to be obscure, and difficult to trace in respect of original meaning. There do also seem to be many Old Norse elements, and this serves as a reminder of the Viking presence that held sway here for so long. Our present language, especially our northern dialects, still both hold, and use, many Scandinavian words.

These pictures show the late Bently Betham and late Jack Cresswell, two of the foremost climbers of their generation, at the top pitch of the famous Chamonix on Shepherds Crag above Derwentwater in Borrowdale. This second ascent was led by Betham who had soloed the first ascent, one of many solo firsts to his credit. Third in the party and behind the camera was the late Austin Barton. (Pictures by kind permission of A. Barton heirs)

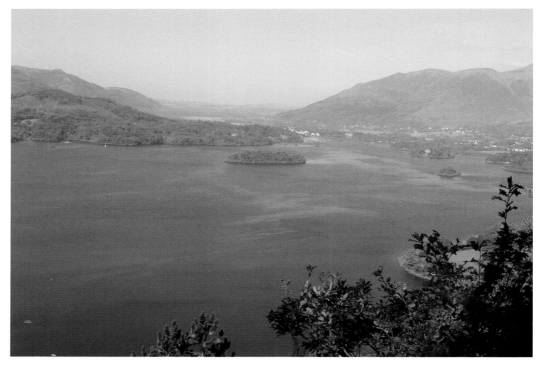

Some of Derwent's islands, from surprise view on the Watendlath Road.

Derwentwater's iconic launches.

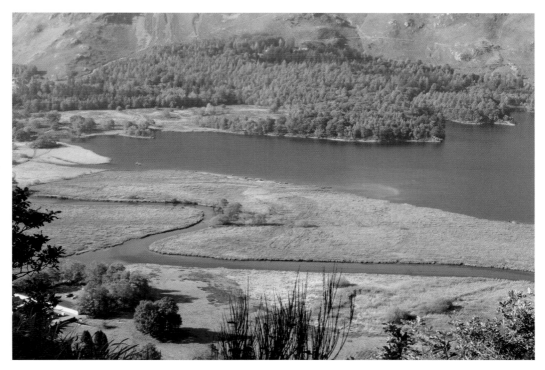

Looking down on the Derwent entering its named lake.

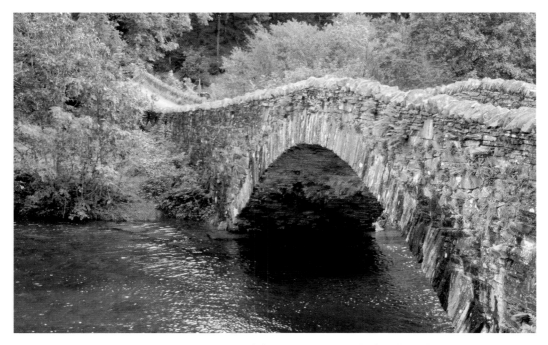

The bridge over the Derwent at Grange, one of the most photographed in the Lake District.

The river just above the Grange.

Above left: The Derwent above the Grange showing the colour in its slate bed.

Above right: The Bowder Stone, another of Squire Pocklington's enterprises.

Islands

Derwentwater has four islands: Derwent Island and Lord's Island, both near the foot of the lake at either side of where Friars Crag juts out into the water; St Herbert's Island, more or less midway down Derwentwater; and the tiny island of Rampsholme, just off Calfclose bay on Derwentwater's eastern side.

The Disappearing Island

There is another island, not often seen, and thought in the past to be somewhat mysterious. This is the 'floating', sometimes called 'disappearing', island. It appears without warning near the River Derwent's entrance into Derwentwater, just below Grange.

Looking back at old books, publications and descriptions, there seems to have been an air of mystery that did the early tourist trade no harm at all. This was in the era when our Lake District circles were being much explored, studied and discussed. This mysterious island was thought to be governed by the moon, or by seasons. Indeed there were numerous explanations, some more tenable than others.

The final, apparently accurate reasons behind the appearance and disappearance of the island turned out to be both interesting and mundane, if one thing can be both. It appears that large quantities of weed were trapping gasses on the lakebed, and periodically this mass, giving every appearance of solid land, would rise to the water's surface. So it could possibly have had something to do with the seasons.

This island, when it appeared, was much used by birds. I can only presume that no one ever tried to stand on it, thank goodness. To sink in such a mass of weed would probably be lethal. It is now many years since the floating island was seen.

There was also said to be a floating island on Coniston Water, although apparently it was blown to land during a storm and subsequently broke up.

St Herbert's Island

As well as St Herbert and St Cuthbert, William Palmer tells us in his *Odd Corners in English Lakeland*, of a legend telling of St Kentigern preaching on this island in around 500. This is too early for the island to then have been named after Herbert. In fact it is more than possible that this date is inaccurate, as the given date for St Kentigern's death is 603. This probable inaccuracy in dates does nothing to dispel the local legends that Kentigern was and did preach in the area in and around Keswick, and possibly Derwentwater. It is not unreasonable to wonder what this island's previous name was. It has probably had several over the years, but the supposed association with St Kentigern gives room to speculate that it might have been thought of as a 'holy' place before the association with the hermit St Herbert.

Collingwood is one of a number of writers who say that St Kentigern set up a preaching cross near the spot where Crosthwaite church now stands on the outskirts of Keswick. It is

also quoted by many that a preaching cross was set up at Crosthwaite by St Cuthbert.

There is no real reason not to believe that both saints could have preached both on the island and at Crosthwaite. As in so many things, there is probably no satisfactory way to really prove or disprove these events, but when a story has lasted a thousand years it is reasonable to suppose that it has some basis in truth.

The friendship between Cuthbert and Herbert is well known and documented. These holy men were to become two of the best-known saints in British Christianity, and shared a friendship of legendary strength and endurance. As mentioned before, their prayer to die on the same day was granted, the date given by Bede being 20 March 689.

St Herbert was known as a teacher hermit, so there is a presumption that the island was visited within the saint's lifetime. The old traditional launching point for boats to this island was Friars Crag; tradition says that St Cuthbert and other brothers of the church would have used this prominent landmark as a launching point. Then it would have been simply the end of a lakeside pathway probably coming from Crosthwaite. Now, much eroded and partially fenced for safety reasons, it is part of a popular walk and must be one of the most photographed places in the Lake District

We are told (by Palmer) that there was a shrine to St Cuthbert on St Herbert's Island, and a series of pilgrimages began there in 1374. Also, an annual St Herbert's Day was recognised by the people of Keswick. He describes them as 'the Dalesfolk beneath Skidaw'.

There was for some years a cell on St Herbert's Island, and many people say that cut and shaped stones are still found there. The current OS map marks the island as having 'the remains of a summer house'. St Herbert's is beyond Ralmpsholme off Calfclose Bay.

Lord's Island

Lord's Island is close to the eastern shore, above St Herbert's Island lying between Friars Crag and Strandshag Bay. According to maps this island still has the remains of an old manor house.

The island was the home of the Ratcliffes, the Earls of Derwentwater. There is a well known and often repeated story of the Ratcliffes, concerning the way that one particular earl met his death. This tale, as in others, has many variants, but the basic facts are accepted as substantially true.

In 1715 the then earl became involved in the Jacobite uprising. As everyone will already know, this failed utterly, leaving many to fly and seek hiding for the sake of their lives. In the aftermath of this failed rebellion the earl was taken prisoner and condemned to death. His wife, Lady Derwentwater, whose feelings were, if anything, more Jacobite than those of her husband, found herself either trapped or kept prisoner on Lord's Island.

It is well known that in the aftermath of rebellion it was sometimes possible to bribe your way from the gallows or the block, with money, land, or often both.

The story tells us that Lady Derwentwater escaped from Lord's Island, climbed up Lady's Rake on Walla Crag, at the top of which horses were waiting to take her across the moor to the coach road. She was carrying gold, and some say jewels, to buy her husband a stay of execution.

We can have no real idea how thickly wooded the shores of Derwentwater were at this time. Most opinions tend to their being even more thickly wooded than they are today. Also the road along the eastern side, the direction in which she escaped, would still have been no more than a rough track. Lord's Island is not far from the lake shore, and escaping straight into the thick woods below the crag sounds both sensible and feasible.

The most puzzling part of this story for me has always been that though she appeared to reach her husband's gaolers in time to negotiate and pass over the bribe, the earl still lost his head. There are unsubstantiated stories of him ordering a new suit of clothes for the occasion. Such things were known to happen!

The part of Lady Derwentwater's story that causes the most general dispute seems to concern whether she could or could not have climbed Lady's Rake. There are Victorian (or thereabouts) lithographs, showing a lady with flying petticoats and hair clinging to a rock face that bears more resemblance to the Alps than to Lady's Rake.

It is some years since I have been up to the base of Walla Crag, or stood at the foot of Lady's Rake, and I accept that it is steep, but I do believe that with help she could have climbed it. Although steep, in some places very steep, there are easier ways up Walla Crag than Lady's Rake. I think it is possible that declaring Lady's Rake as her route was all part of the romance added later (for the tourists), and although she ascended Walla Crag, Lady Derwentwater could well have taken an easier route. Let me say that nothing on this crag could be termed exactly easy, but in the circumstances some parts are more possible and practical than others.

The route to a degree would not matter to anyone desperate to escape and reach her husband, the important thing would be to reach the top and gain the coach road safely. It is often said that she was met here by a private conveyance. Escape by all accounts she appeared to do, and the bribe was paid and failed, or so we are told. As mentioned earlier, I always think that the failed bribe was the most interesting circumstance of the Derwentwater's story, in all its versions.

One last comment: did she attempt such a climb in petticoats? The way she would have been dressed is often given as a reason for the impracticality of such an ascent. When this is put forward as an argument I often think of what the early lady climbers achieved in skirts. But skirts in Lady Derwentwater's case? I doubt it. Woman in this part of the country have always ridden astride when practicality or circumstance made it necessary. The lady was in desperate circumstances in desperate times and she would have dressed appropriately.

A note: within hours of Lord Derwentwater's death a fine display of aurora was seen above the lake; this phenomenon has since been called Lord Derwentwater's lights.

Derwent Island

Easily visible on the right from the lakeside path to Friars Crag, Derwent Island was for some years privately owned, but now belongs to the National Trust. There is a large house on the island.

Mining in and around the Keswick area blossomed and grew into a major industry in the mid-1500s. One of the driving forces behind this expansion was the influx of skilled German

miners. This workforce, although it was to be of ultimate benefit to both the industry and the area, was not universally welcomed.

For a number of years a colony of these émigré German miners made their homes on Derwent Island, and it is often said that this choice was made for reasons of security. Not all the German incomers lived here, however; some, we are told, did live and lodge in other areas of the community.

I confess that I do not know how 'proven' it is, but I have also read of Romans living on Derwent Island. However the undisputed 'king' of Derwent Island has to be a former owner, Joseph Pocklington, a famous philanthropist and eccentric. He bought Derwent, then called Vicars Island around the 1780s and proceeded to transform it.

He appears to have had an interesting and often eccentric taste. A druid temple and standing stones apparently added to the somewhat Gothic architecture that he seemed to prefer over and above his other interests, which appear to have been many. 'King Pocklington' had a taste for riparian entertainments that were to become famous, if not infamous. He and his partner, Peter Crosthwaite, were responsible for the renowned Derwentwater regattas of the 1780s, and these events have gone into legend.

Apparently the first such regatta was held on Bass Lake in 1780. This event obviously sparked ideas and perhaps some rivalry, for it appears to have been decided that whatever Bassenthwaite could do, Keswick could do better. The following August, 1781, was to see the first Derwentwater regatta.

The event drew huge crowds, who spread both along and on the lake, Crow Park being an ideal vantage point. Seeing these events described, they appear part regatta, part carnival, part sports day, plus fireworks, entertainers and a waterborne mock battle. They must have been wonderful.

Like most things, the events seem to have had their highs and lows: bad weather, some local disagreements etc. There apparently were occasions when mock battle seems to have tipped into reality. In spite of such happenings the yearly regattas lasted until 1790 and have for evermore made their mark on local history. Pocklington sold Derwent Island in 1796.

Winter Entertainment

There have been various periods of 'riparian' entertainment since Squire Pocklington. I have been told of regattas and swimming galas held on Derwentwater between the wars, but some of the most often repeated and remembered stories tell of the bitter winters early in the twentieth century.

For a number of winters Derwentwater froze to such an extent and thickness that it was possible to walk to Derwent Island. Also, there are many tales of skating parties, complete with braziers, and even an ox roast out on the ice. I have seen Derwentwater part frozen on a number of occasions, but nothing to match past descriptions. However, my husband's grandfather spoke of skating from Workington to Cockermouth on the River Derwent and it must have been within this same period; he also talked of cars being driven on lake ice.

Looking down Borrowdale towards the Gates, with Glaramara on the right. From here the valley appears enclosed.

Looking into Borrowdale from the Glaramara path, Castle Crag can be seen on the left.

Pictures like this give a true impression of the valley's glacial past.

Above left: The Derwent just below Seathwait Farm, still little more than a stream.

Above right: A few yards later, the Derwent is a budding river.

Looking up towards Great End, with Esk Hause central.

Looking up into Esk Hause, the cradle of the Derwent.

Launches

One of the most popular and rewarding ways to view Derwentwater and its surrounding hills is from the lake itself, and to most people, tourists and visitors alike, this means a trip on the famous Derwentwater launches.

Run by the long-established Keswick Launch Company, these boats are almost as famous as the lake itself, and circle Derwentwater to Keswick in the summer and winter. There are six request stops encircling the lake (stand on the landing stage and wave), and one such stop is Lodore close to the famous Lodore Falls Hotel.

This immediate area is itself named 'Lodore' and, according to Diana Whaley, the name could possibly mean 'low door', named after the gorge between Shepherds and Gowder Crag, which is the route taken by Watendlath Beck on its way to becoming the famous Lodore Falls.

7

Borrowdale

Borrowdale, its name associated with both river and fortification, is one of the most famous valleys within the Lake District. Parts of Borrowdale show evidence of occupation from the Iron Age onwards, and there are opinions that some of this evidence of occupation is even earlier. Of course many people will be aware of the 'Axe Factory' in Langdale. Early occupation of Borrowdale and other Lakeland valleys is not beyond the realms of possibility.

Looking at the OS map of this valley you will see a number of 'dubs' marked along the Derwent's length. In Cumbrian dialect 'dub' is usually regarded as another name for puddle. It is, however, also used to describe an artificial or partly artificial pond or fish trap used by monks and other earlier societies.

Usually situated at the edge of a pond or lake, a dub often began life as a puddle or 'Bog Hole'. These features were artificially deepened and a removable entrance of stones or mud added adjacent to the larger body of water. Fish were encouraged or driven into these traps and then walled in. Some dubs were used in an early form of farming, with young fish being trapped and fattened. There is a famous Char Dub in Ennerdale, a valley that also shows evidence of early occupation. Whether or not the areas marked as dubs in Borrowdale were used as the name suggests, or how early this practice began, is a matter of debate.

Grange

There is a dub marked just below Grange Crags and the village of Grange itself, with its beautiful bridge spanning the Derwent, must be one of the most painted and photographed scenes in the area. This picturesque hamlet stands at what most locales regard as the entrance of Borrowdale. Grange is easy to access, by foot, boat or car and it is an obvious and popular tourist destination. Grange features in the famous Hugh Walpole's works, as indeed does Watendlath, just over the fell.

Grange itself, we are told, was the scene of an infamous murder early in the last century. Like all such stories there are a number of versions, but the general basic facts all appear similar. A couple were on honeymoon in the area, most versions say at the Lodore Falls Hotel, and the bride was found strangled near the renowned and beautiful Borrowdale Beeches.

An obvious and typical glacial valley, this lower end of Borrowdale is narrow and twisting, with high, wooded crags. Here the Derwent runs over a spectacular blue-green Borrowdale slate bed a few feet below road level. The road itself is to the left of the river, an excellent and much-used riverside path winding through mainly birch woodland passes along the right. River, road and path run virtually side by side to the Gates of Borrowdale.

The Bowder Stone

Before reaching the 'Gates', to the left of the road is a clear sign to 'Bowder' or 'Boulder' Stone. This enormous rock is spectacularly perched and we are told has been visited by tourists since the seventeenth century.

Squire Pocklington of Derwentwater fame is (as far as I know) the first person credited with making a feature of the rock, and even arranging a 'guide' in the form of a local woman who inhabited a small cottage built close to the feature. There is still a small slate building close to the stone, but whether this is or is not the original I am afraid that I do not know, although I have spoken to people who bought lemonade and other refreshments here in the 1930s, which may give a clue as to its age.

One persistent local story concerning the squire and the Bowder Stone states that originally the stone was not quite so spectacularly perched, and Pockington had the base dug out with the express idea of turning it into a feature.

There are a set of wooden steps specifically erected to make it possible to climb the Bowder Stone, and it is also possible to shake hands through a gap at the very base of the boulder. I admit that I have never dared.

The Bowder Stone is still much visited, there is a car park and a well-marked woodland path.

The Gates of Borrowdale and Castle Crag

Not far beyond the Bowder Stone, the valley is at its narrowest, and this area is known as the 'Gates of Borrowdale'. It is almost impossible to know how long this title has been used; attempting to date it has caused some differing opinions.

The 'Gates' are overlooked and guarded by Castle Crag. A great deal has been said and written about this crag and, in spite of its name, it looks much more like a castle from a distance than it does on closer inspection. It is, however, accepted that it occupies a good defensive position in regard to access to the head of Borrowdale, and there is evidence of past occupation. There has even been suggestion of Roman occupation here, Borrowdale being a rich mining area. There are some signs of past, and relatively recent, slate quarrying at and around Castle Crag.

One of the many stories concerning this crag talks of it being the home of an ancient hermit. We know with certainty that it was the home, for part of the year, of the famous Millican Dalton, the Professor of Adventure, also known as the 'Hermit of Castle Crag'. The fascinating book by M. D. Entwistle about Millican Dalton's life is subtitled *The Life and Times of a Borrowdale Caveman*. He didn't, however, seem averse to people, just the

modern lifestyle. This 'hermit' acted as Lakeland guide and climbing instructor to many. Borrowdale's crags saw some of the earliest tourists and climbers, and were to prove both an introduction and inspiration for many early 'alpinists' even before Daltons time. He died in 1947.

I am sure that climbing friends will forgive me for mentioning the awe and trepidation with which some early visitors viewed the Gates of Borrowdale. As mentioned previously, the valley – indeed most of the Lake District – must then have looked a very different place, with only rock-strewn footpaths and sheep trods to guide the traveller. Also, some of these paths had been smugglers' routes and superstition played no small part in guarding them.

There are a number of not altogether apocryphal accounts (so I am led to believe) of intrepid gentlemen of the century before last, or thereabouts, dressed and kitted fit to attempt the Triffhorn or its equivalent, being startled on meeting farmers' wives on what were described as the most 'treacherous' of paths.

These redoubtable ladies were usually on horseback and perfectly at ease without benefit of a saddle and only a length of rope for a halter; their arms festooned with baskets of butter, cheese and eggs as they made their way to market. What they thought of the incomers and their costumes, as they wished them good day, can only be guessed at.

Castle Crag is on the right of Derwent and approachable by a marked path through Rosthwait, one of the hamlets of upper Borrowdale. There is also a good path from Grange. Rosthwait is one of four hamlets in upper Borrowdale. The others are Stonethwait, Seatoller and Seathwait.

Once beyond the 'Jaws' the valley opens out and road and river separate to come together again at Seathwait, close to the head of Borrowdale.

Upper Borrowdale

Reputed to be one of the wettest places within the British Isles, Borrowdale has seen a number of occupiers, owners and tenants, among them the monks of Furness who were gifted the valley by the Lords of Derwentwater. Now of course, it is part of the Lake District National Park.

The place names of the hamlets of upper Borrowdale sound descriptive of the valley, what it is now and possibly how it was: Rossthwait, 'the clearing by the cairn'.

A branch left of the main road leads to Stonethwait, 'a stony clearing', above which lies Langstrath, or 'long' valley. Langstrath is part of a popular route leading eventually over to Langdale. Langstrath Beck is one of many tributaries of the Derwent.

Next is Seatoller, 'an interesting and problematic name' (Diana Whaley) one possible meaning 'the sheiling site with the alders'. Seatoller sits at the foot of Honister Pass, the main road crosses the pass here leading eventually to Buttermere.

A side road leads to Seathwait, 'a clearing where sedge grows'. The metal road ends at the farm here, and you can look upwards towards the cradle of the River Derwent and the hills that feed its source.

The Cradle of the Derwent

Looking down Borrowdale from Seathwait Farm, this flat-bottomed valley appears completely enclosed. A true glacial valley across which the budding River Derwent snakes, this part of Borrowdale gives the impression of being protected by a ring of ridge and fell. Glaramara, Esk Hause, Great End, Dale Head, Brandrath are just some of the hills that surround this glacial plane.

I hope that it is not regarded as too fanciful but I often think of the Derwent as having a cradle as much as a source, for it is not fed by a 'mother' stream springing from the rock, as some rivers are. The Derwent is given life by water that seeps, soaks and runs from the surrounding fells.

There is a slight difference of opinions as to where the Derwent truly begins, but by far the majority agree and accept that the river begins in Esk Hause above Sprinkling Tarn. The most direct path from Seathwait to Sprinkling Tarn and Esk Hause is via Grains Gill and the famous Stockly Bridge, clearly marked on the OS map.

The Source

Water gathers in a rift on Esk Hause and from here tumbles down the hillside gathering tributaries major and minor, including the water that streams from Honister and Langstrath. It is well worth looking at an OS map to see how many becks and streams there are, far more than I have the space to mention here. In effect the young River Derwent drains an entire valley, a valley that is said to be one of the wettest in Great Britain.

Two lakes, three major towns, numerous villages and hamlets, 2,500 feet and 25 miles later this wonderful spate river meets the sea.

Looking from Esk Hause, the Derwent's source, towards Sprinkling Tarn.